A CHANGING WORLD

A CHANGING WORLD

New England in the Photographs of Verner Reed

1950–1972

Edited and with an essay by
John R. Stomberg

Commonwealth Editions / Beverly, Massachusetts

in association with

Historic New England / Boston, Massachusetts

Library of Congress Cataloging-in-Publication Data

Reed, Verner, 1923–
 A changing world : New England in the photographs of Verner Reed 1950/1972 / Edited,
and with an introduction by, John R. Stomberg.
 p. cm.
 ISBN 1-889833-93-2 (hardcover) — ISBN 1-889833-94-0 (pbk.)
 1. Photography, Artistic — Exhibitions. 2. Photojournalism — New England — Exhibitions. 3.
Reed, Verner, 1923 — Exhibitions. 4. New England — Pictorial works — Exhibitions. 5. Historic
New England (Organization) — Photograph collections — Exhibitions. I. Stomberg, John R.
(John Robert), 1959– II. Historic New England (Organization) III. Title.
 TR647.R3926 2004
 779'.9974 — dc22 2004015303

Frontispiece: *Dreamland,* Tunbridge, Vermont, 1963

Book design by Dean Bornstein
Printed by Capital Offset Company, Concord, New Hampshire
Bound by Acme Bookbinding, Charlestown, Massachusetts

Published by Commonwealth Editions
an imprint of Memoirs Unlimited, Inc.
266 Cabot Street, Beverly, Massachusetts 01915
www.commonwealtheditions.com

in association with
Historic New England
141 Cambridge Street
Boston, Massachusetts 02114
www.HistoricNewEngland.org

FOREWORD

When William Sumner Appleton began collecting photographs for the new Society for the Preservation of New England Antiquities in 1910, few museums recognized the value of photographic images. For more than ninety years Appleton's vision has shaped the work of the organization, now known as Historic New England. Where buildings could not be saved, photography preserved a visual record. Photographs of buildings, people, and artifacts help tell the stories of the past that Appleton considered essential to saving New England's heritage. They also provide an invaluable resource for scholarship, interpretation, and enjoyment.

The work of photographer Verner Reed enriches the collection with superb images from the third quarter of the twentieth century. Photographs of Vermont's Tunbridge Fair reflect New England's deep roots. Images of John F. Kennedy and Robert Frost remind us of the region's visionary contributions to America. Pictures of urban and rural life remind us that we are all players on the stage of history. Reed's photographs do all that Appleton expected—documenting the passing scene, telling stories, recording places and faces—but they go beyond that.

While all photographs provide a record, only some of them achieve the level of art. Verner Reed's photography is equally important as historical record and as artistic vision of this region and its people. Verner and Deborah Reed's gift of Verner's images to our Library and Archives is an extraordinary contribution to future generations. We are very grateful. With this book, we introduce the collection and share some of its treasures with you.

Boston, Massachusetts
April 2004

Carl R. Nold
President and CEO
Historic New England

ARTIST'S STATEMENT

"A photograph should speak for itself." If it has captured the essence of the moment, no explanation is needed.

I loved photography even as a child with my Brownie box camera. This love was further enhanced when, in 1936, I saw the first issue of *Life* magazine. Twelve years later, when I became serious about photography, Ansel Adams and Cartier-Bresson became my inspirations.

I ran the usual course of portraits, babies, weddings, and sent photo essays on spec to magazines. Then quite by accident, I crossed paths with the *Life* bureau chief, sans photographer, and so began a six-year relationship which I kept on a freelance basis. This gave me independence and the freedom to also do my own work. I had the best of both worlds.

I tried to be invisible taking pictures. I rarely posed people. I never used artificial light. I tried to be true to the feeling of the moment, and when I took the picture, I could usually see the final print in my mind.

People often ask me why I became a photojournalist. I am not sure that I did entirely. But to the extent that I did, it was, in part, the influence of that 1936 *Life* magazine. Working for *Life* and *Vermont Life* was simply the most interesting and rewarding aspect of photography for me.

I am fortunate to have had the help of photo historian John R. Stomberg, who selected and wrote about the images in this book. With patience and perseverance, he examined over 26,000 negatives, resurrecting many that I had missed. He then caused order to emerge from chaos and made choices for both of us, most of which I agreed with.

Under the aegis of SPNEA [now known as Historic New England], the safe storage and preservation of my negatives has come true, something most photographers only dream about. Many thanks to Jane Nylander, SPNEA president emerita, who introduced the idea of working with SPNEA, to Ken Turino, exhibitions manager, and especially to Lorna Condon, curator of Library and Archives, for her help with this project. Thanks to Bethany Taylor, who filed and indexed all the negatives. To my daughter, Mary, whose computer skills supported her father in this new age of technology, thank you. And, of course, thanks to my wife, Deborah, who had the original idea for an exhibition of these photographs while I could still see them and who did the initial selection of images from that sixty-year-old jumble of negatives. Her devotion has been the mainstay of this endeavor.

Verner Reed
Falmouth, Maine
April 2004

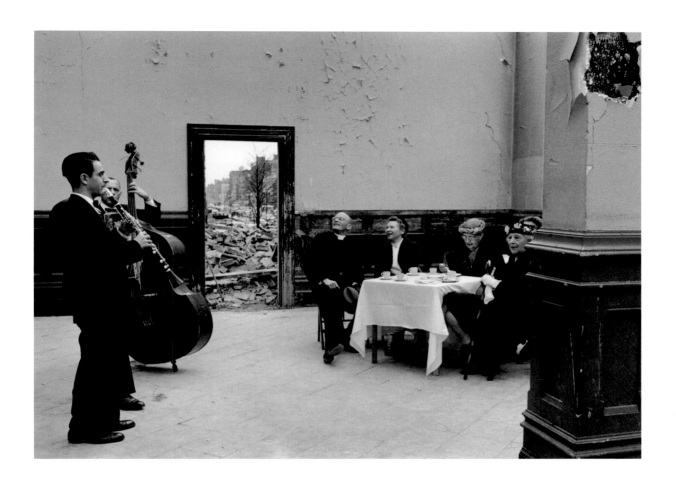

A CHANGING WORLD

New England in the Photographs of Verner Reed, 1950–1972

THE photograph is called *Brunswick Hotel,* and it was made in 1957. In it a priest and four well-dressed women share a table. The priest wears a suit. There are teacups on the table, which is draped in a clean white tablecloth. With the trio of musicians serenading the seated group, this scene has all the hallmarks of afternoon tea at one of Boston's fine old hotels. Yet, as the details reveal, this would not have been a typical affair. The guests remain in their overcoats. Rather than being in a crowded dining room, the lone table seems temporary and oddly out of place. The column in the foreground is badly damaged, and the paint is peeling off the wall in the background. Through the missing door, a mound of construction debris threatens to spill into the room. And yet, the music plays on.

This image typifies Verner Reed's New England. It captures the moment when a downtown Boston hotel was being demolished. Patrons, who for years had met there for afternoon tea, have arranged one last gathering. They sit, literally in the ruins of their past, in seeming denial of the changes that

surround them. Reed, though, has selected his moment carefully, and his choice suggests a nuanced interpretation. The people do not all pay strict attention to the musicians. The priest, for example, seems to be looking toward the ceiling—or what remains of it—and some of his companions seem likewise distracted by their surroundings. In fact, the demolition work was ongoing (the hotel was being replaced by a modern building leased to IBM), and on this grand, metaphorically rich occasion, the tea drinkers are completely aware of the changes that surround them.

This visual triple entendre is not uncommon in Reed's photography. His best work presents an obvious subject at first, usually with a second, countervailing meaning lurking just below the surface. Quite often, a further layer of significance lies buried just a bit deeper into the work. In the example just cited, we have the group enjoying afternoon tea and a small concert, but the surrounding demolition lends a very different tenor to the event. Reed clearly relished the simple irony that emerges between the decorum maintained by the sitters and the decrepitude of their environs. Yet, his chosen moment reveals a final twist: these Bostonians recognize their situation; they celebrate long-standing traditions even as they acknowledge changing times.

In the 1950s, life in the United States was indeed changing. As the chill of the Cold War spread across the world, America fell victim to its abounding self-confidence. With the World War II victories in Japan and Europe, the country felt somehow justified in divvying up the globe into two spheres: theirs and ours. The attendant hubris of this de facto empire-building characterizes the era as well as the (illusionary) notion of stability so often cited for it. Reed's photographs often seem to evoke the dichotomy between surface swagger and internal debate. In this way his work exemplifies an era when, if stability was to be found, it was only that of a country running down the up escalator, and Reed's photographs seem to hint that the escalator was gaining.

Verner Reed first turned to photography in the late 1940s. He was working as a furniture maker and needed good documentation of his finished pieces. He soon took an interest in the medium itself as a mode of self-expression. Leaving his home in Vermont, he moved to Boston and there spent much of his time photographing the city's streets and inhabitants. He also sought out some freelance work on the side. These two worlds—creating images of life in and around the city and earning a living from photography—came together serendipitously in June 1953, when Reed spent an afternoon making images of protesters in front of the Massachusetts State House. Ethel and Julius Rosenberg had been sentenced to death in 1951 for conspiracy to commit espionage by providing information about nuclear weapons to the Soviet Union. The trial had become an international controversy, and many felt that if the couple had confessed to the charges during their twenty-six months on death row they might have been spared. Their refusal had turned them into martyrs for the left and targets of unprecedented vitriol from the right. The Rosenbergs were scheduled to be (and in fact were) executed on June 19, 1953. As the flurry of last-minute attempts to obtain a stay of execution were heard in court that week, the emotionally charged conflict spilled into the streets. There, supporters of clemency clashed with those who favored the death penalty. There, too, a writer for *Life* magazine struggled to cover his story without the aid of a photographer. Seeing Reed busily making photographs, the reporter asked if he would be willing to cover the protests professionally. Reed accepted.

In the set of images he made that day in Boston, Reed captured the story as it was reflected on the faces of people not directly involved with either the crime or the trial. They carry banners and placards pleading for clemency or describing the Rosenbergs as the "Knife in America's Back." A particularly compelling image depicts a row of elder citizens sitting on the bench incorporated into Augustus Saint-Gaudens' *Shaw Memorial*. Behind and above this group, someone has stuck signs directly onto the famous sculpture with messages such as, "Go Ahead! Burn Ethyl . . . Julius Too." With this gesture, the protesters tried to co-opt the patriotism of the memorial celebrating Civil War bravery to show support for those condemning the Rosenbergs. Reed's photograph contrasts the "patriotism" of the inactive political spectators on the bench against that of the famous regiment; it also established the mode of interpretative multi-valance that would characterize so much of his work.

Ultimately, Reed's Rosenberg photographs were not published in *Life*, but he did go on to cover New England for the magazine from 1953 to 1958, always on a freelance basis. Henry Luce, the magazine's notorious publisher, offered him full-time work in 1956, but Reed declined. Working for the magazine full time would have involved a loss of personal time and autonomy—not to mention a move to New York—sacrifices Reed was unwilling to make.[1] Reed's photographs were featured in other national magazines such as *Fortune* and *Time,* as well as regional publications including *Vermont Life;* he also worked for several New England newspapers. Whenever his photographs were published, Reed's intentions were overlaid by new interests on the part of the magazine. Picture editors and text and caption writers, as well as the basic slant of the magazine, shaped how a photographer's work would be interpreted in its published state.

Life had always taken a strong editorial stance. It supported a view of the country politically as the dominant power in the world and culturally as enjoying enduring, homespun traditions. In its original prospectus, Luce had emphasized his intention to instruct visually, saying the magazine's goal was "to see life; to see the world; . . . to see and take pleasure in seeing; to see and be amazed; to see and be instructed."[2] Luce clearly intended to take a stand on issues with his magazine. In a famous 1941 editorial, "The American Century," Luce argued that Americans needed to accept their dominant role in the world, and by virtue of that power, "to exert upon the world the full import of our influence, for such purposes as we see fit and by such means as we see fit."[3] And later that year, he re-affirmed the magazine's role, saying, "*Life* helps great masses of people come to grips with the world as it really is—helps them make more intelligent decisions."[4] Decisions, so defined, were intelligent when they adhered to the magazine's image of the country as striding boldly forward in its role as a world power while continuing to value greatly its cultural heritage.

One of Reed's favorite *Life* assignments, and one of his most complete photo essays in the magazine, dovetailed perfectly with the magazine's cultural politics. The story covers the fanciful wedding of dolls at the home of children's book author Tasha Tudor. By the 1950s, the photo essay was well established as a method of storytelling, and no magazine in the United States was more famous for its use of photographs to carry a narrative than *Life*. In the Tasha Tudor piece, "A Wedding in a Land of Dolls," the editors used a full-page introductory image of the betrothed at the altar—the establishing shot that could carry the whole story alone if needed. On turning the page, the reader finds a two-page

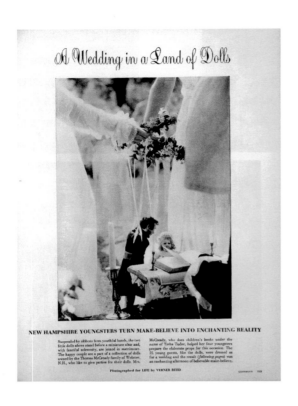

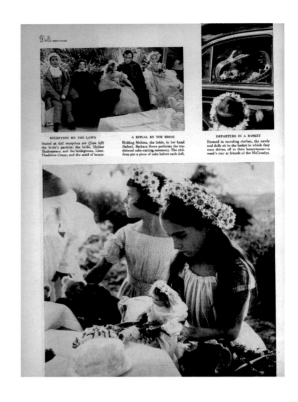

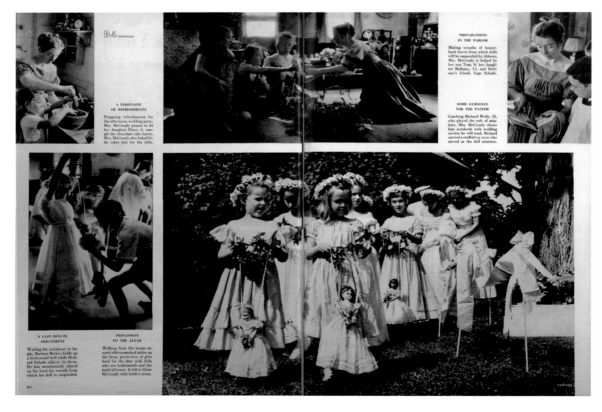

Counterclockwise from top left, Reed's photo coverage of a doll wedding at
the home of Tasha Tudor, from *Life*, September 12, 1955.

spread starting in the upper left with behind-the-scenes preparations and ending in the lower right with the wedding processional. The last page includes the happy couple in a basket awaiting departure for their honeymoon and an image of a girl helping the doll bride cut her cake. Together, these photographs display a kind of Edenic ideal, a return to innocence.

Tudor famously eschewed the trappings of modern living, preferring instead a carefully constructed make-believe world based on nostalgia for pre-modern America. It was the perfect assignment for Reed. The entire lifestyle that Tudor presented looked back toward an idealized colonial past. One of the more persistent complaints about the country as it modernized was the loss of individuality as standardized products from clothes to automobiles became increasingly available. Tudor's lifestyle knowingly opposed this encroaching homogenization. For the dolls' wedding photo shoot, for example, she wears a simple handmade frock. In one image, Reed shows her in the kitchen, stirring cake batter in an old-fashioned ceramic bowl (note, too, the pitcher just behind the bowl), with a delicate light filtering in from an unseen window. This is an image that could have been made almost anytime after the Civil War. Reed allows only occasional reminders of the true date in this set of photographs—a clock, a distant lamp, and the car in the final image—as if to reinforce the willful disregard for reality involved with the whole event.

To this day, Reed cites the Tasha Tudor shoot as one of the most important of his career—he remembers clearly the days he spent at Tudor's place. He also met photographer Nell Dorr while working there. Dorr, a friend of Tudor's, tended to work on the fringes of the photography world and, to some extent, her artistic approach interested Reed more than his own commercial work for the leading picture magazine of the day. Dorr used the medium in a deeply personal, poetic manner. She focused on the issues of greatest concern to her, especially the relationship between a mother and her children. Reed felt strongly encouraged by the private nature of Dorr's work—that she concentrated on subjects dear to her own heart, especially children.

Reed also spent a great deal of his time looking at youth and giving special consideration to the role of children, not just in the family but in society as a whole. We find images of stoic farm children tending the fields, such as the girl harvesting potatoes, and cocky city kids for whom the streets were a natural habitat. While Reed's photographs of adult New Englanders typically captured them as they glanced, Janus-like, forward and backward, caught between their yesterday and their tomorrow, his images of children seem to vacillate between freezing them in their innocence and probing them for clues to their future. A particularly poignant image, and an example of the latter, depicts a middle-aged farmer as he looks gently at two boys who are not likely to follow in his footsteps. Reed's composition makes the man's world clear. He sits in front of a barn, carefully framed by an open window fully occupied by two staring oxen. This opening visually binds the man's world to that of the farm animals but divides him from that of the boys. If the cattle identify the man and his world, then the opposing area of the photograph inhabited by the children is literally a blank slate. As so many of Reed's photographs do, this image captures a moment that reveals the transitional nature of the age.

Culturally, the 1950s and 1960s were an electric time in New England as people embraced the new even as they faced hard decisions about holding onto the past. The prewar promise of the American

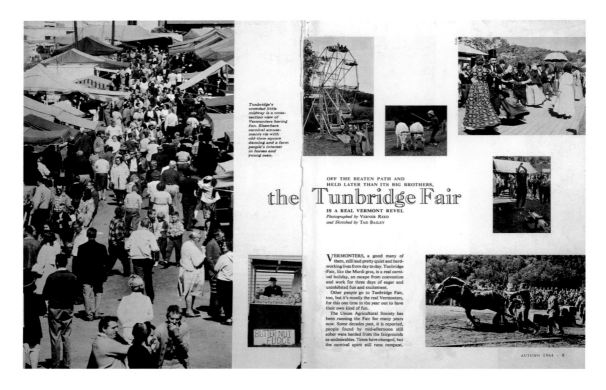

Tunbridge's crowded little midway is a cross-section view of Vermonters having fun. Elsewhere carnival amusements vie with old-time square dancing and a farm people's interest in horses and young oxen.

OFF THE BEATEN PATH AND HELD LATER THAN ITS BIG BROTHERS,

the Tunbridge Fair

IS A REAL VERMONT REVEL

Photographed by VERNER REED and Sketched by TAD BAILEY

VERMONTERS, a good many of them, still lead pretty quiet and hard-working lives from day to day. Tunbridge Fair, like the Mardi gras, is a real carnival holiday, an escape from convention and work for three days of eager and uninhibited fun and excitement.

Other people go to Tunbridge Fair, too, but it's mostly the real Vermonters, for this one time in the year out to have their own kind of fun.

The Union Agricultural Society has been running the Fair for many years now. Some decades past, it is reported, people found by mid-afternoon still sober were herded from the fairgrounds as undesirables. Times have changed, but the carnival spirit still runs rampant.

AUTUMN 1964 · 5

highway system and electrification was becoming fully realized in the rapidly expanding postwar economy. Small farms gave way to larger agri-businesses; thousands upon thousands of acres of meadows and woodlands were lost to newly built suburbs; supermarkets replaced fruit vendors and butchers; and even town and county fairs were being eclipsed by regional and national fairs made accessible by the automobile.

The farmer and boys discussed above were actually at one such fair, a county fair in Vermont. Over the years, Reed (who had moved back to Vermont in 1960) often visited the Tunbridge Fair, and in 1964 *Vermont Life* published a major photo essay on the fair, which the editors referred to as "Vermont's own" World's Fair.[5] The essay featured almost twenty of Reed's photographs, along with drawings by an artist, laid out across four consecutive two-page spreads. The Tunbridge Fair had a long and storied past, with a well-earned reputation for being the time and place where stoic Vermonters let their hair down—and more. The article cites a story that was probably apocryphal but nonetheless telling. It seems that in times gone by all people at the fair who were still sober in the afternoon "were herded from the fairgrounds as undesirables." During the 1960s, the organizers of the fair tried increasingly to shift the attention from the drinking and gambling of the midway to activities that reflected more favorably on agrarian life. *Vermont Life,* too, chose to emphasize the fair's more family-friendly aspects: an elderly woman sells homemade butternut fudge, a child tries his hand at leading young oxen, and couples demonstrate traditional country dances in wardrobes carried over from a previous time—all on the first page. But, as the reader progressed through the story, the lingering seamy side to the fair emerged, with scenes of people drinking, gambling, and watching the ubiquitous "girlie show"—but "from a safe distance," the magazine assured its readers.

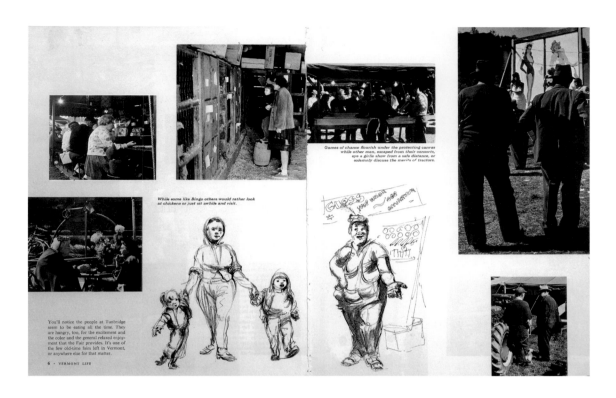

Selected pages from the essay on the Tunbridge Fair, from *Vermont Life*, Autumn 1964.
Reprinted with permission from *Vermont Life* Magazine.

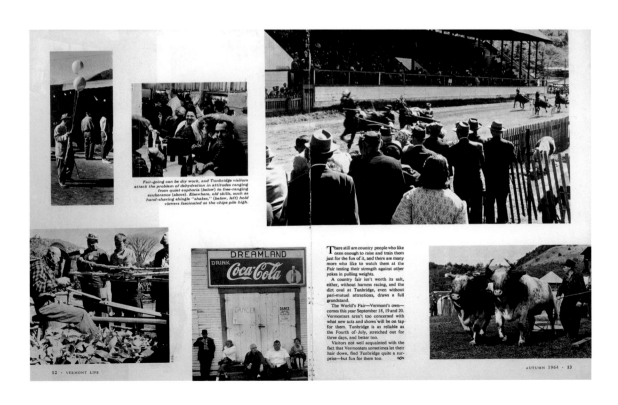

Images of community celebrations such as the fair have appeared throughout the history of visual culture, and for centuries these images have been used metaphorically to critique human behavior and the role of individuals in society. Reed's images of the Tunbridge Fair offer the same glimpse of life's rich pageantry on display in microcosmic form. He found a wide range of human emotions in the faces of the fair-goers. Examples of extreme skill and complete depravity were on display, with crafts people and animal tenders exhibiting their talents alongside those who overindulged at the beer tents. The fair brought people of divergent backgrounds and codes of behavior into close proximity. It was a place where a broad range of human endeavors was simultaneously visible. Social strata that rarely crossed paths during the rest of the year jostled together for three days each year, and for Reed this was the story—not just what was done, but who the actors were. The spectacle was less the event than the audience. Reed's fair images place the visitors in the foreground. In the *Vermont Life* spread, photographs taken from a visitor's sight line are mostly limited to the first page. For the remainder of the article Reed was out in front of, or behind, the spectator—watching the watchers.

Reed used this conceit throughout his photographic career. Asked to cover events, he was always at his best looking back at the viewers. It becomes clear that people and their reactions stirred him more than the ostensible subject. Though he made terrific formal compositions throughout his career— images devoid of humans and satisfying for a variety of other reasons—Reed's photographs of New Englanders have become his signature work. Profoundly intelligent, he has created a body of images that chart the conflicting emotions and desires that can delineate personality. Reed's photographs do not disparage his subjects; his vantage point is not one of superiority but that of a fellow citizen. Indeed, the period of his greatest activity, the 1950s and early 1960s, was a complex time, and he seemed to photograph in order to comprehend. Plato described understanding as a light one moved toward through the dimness—a tunnel or cave—of incomprehension. Reed, too, searched for understanding, looking through the tunnel of his lens toward the light of perception on the other side. We see in the captured moment of his images fleeting, piquant glimpses of the times that carried within themselves the richness of the past, the abundance of the present, and the foreboding of the future.

John R. Stomberg
Williamstown, Massachusetts
April 2004

1. Had Reed accepted, the magazine would also have owned all the negatives made while on assignment. That he remained freelance throughout his career for *Life* allowed Reed to maintain not only possession of his negatives, but of the rights to the images and to give them away as he did to SPNEA/Historic New England.
2. Henry Luce, quoted in Loudon Wainwright, *The Great American Magazine: An Inside History of LIFE* (New York: Alfred A. Knopf, 1986), 33.
3. Henry Luce, "The American Century," *Life*, 17 February 1941, 61–65.
4. Henry Luce, editorial, *Life*, 15 December 1941.
5. The real World's Fair was in full swing at Flushing Meadows in Queens, New York, in 1964.

VERNER REED CHRONOLOGY

1923	Born in Denver, Colorado.
c. 1934	Took first photographs with a Brownie camera.
1936	Learned how to develop 35 mm negatives.
1941	Graduated from Milton Academy, Milton, Massachusetts, and entered Harvard College.
1942	Left Harvard College to enlist in the U.S. Army Air Corps.
1942–46	Served in China, Burma, and India.
1947	Following World War II, moved to Stowe, Vermont, and became a furniture maker.
1949	Learned to photograph by studying the writings and work of Ansel Adams and Henri Cartier-Bresson.
1950	First published photograph appeared in the *Burlington Free Press,* Burlington, Vermont.
1952	Moved to Boston to work full time as a professional photographer.
1953	Worked for *Life* magazine as a freelance photographer covering New England. From 1953 to 1958, photographed approximately 125 assignments for *Life*.
1954	Work was the subject of a photography exhibition held at the DeCordova Museum, Lincoln, Massachusetts.
1956	Work was exhibited for a second time at the DeCordova Museum.
1958	Resigned from *Life* in protest over an article about the nuclear bomb.
1960	Returned to Vermont, continuing to photograph for *Vermont Life* and other publications. Began a career as a sculptor.
1973	Moved to Pemaquid Harbor, Maine, to operate a saltwater farm and raise sheep. Continued to sculpt and photograph.
1980	Moved to Falmouth, Maine. Began a career as a jewelry maker and silversmith.
1998	Retrospective exhibition of photographs held at the newly reopened Payson Gallery, University of New England, Portland, Maine.
2002	Donated archive of more than 26,000 negatives to the Society for the Preservation of New England Antiquities.
2004	Retrospective exhibition of photographs organized by Historic New England (formerly the Society for the Preservation of New England Antiquities) held at the National Heritage Museum in Lexington, Massachusetts.

TELLING THE STORY

The images in this section were conceived to work together with other photographs to tell a story as part of a photo essay. They allow us to analyze the ways photography has been used to create narratives. Much of Reed's earlier professional work was reportorial in nature. With the Rosenberg trial shoot in 1953, for example, he covered the story with the pages of a magazine in mind, creating establishing shots, medium distance views, and close ups of the encounters between people on both sides of the issue. Later in the decade, he had three assignments to photograph then Senator John F. Kennedy, two for *Life* and one for *Time*. One shoot, for which he had to travel to Hyannisport, Massachusetts, he recalls with particular fondness: "It was a rainy afternoon, and I spent all of it there. I took a great many pictures, not only of JFK but also of him and Jackie together." Reed followed Edmund Muskie in the Maine gubernatorial election from the tense moments as the first results came in to the elation of victory. As evidenced in this section, Reed made numerous photo essays. Some, such as the Rosenberg trial or the session with John F. Kennedy, must have seemed historically significant even then. Others, like the shoots at Tasha Tudor's farm or the country auction in Vermont, may have seemed of less import then but, in retrospect, have come to speak volumes about the times.

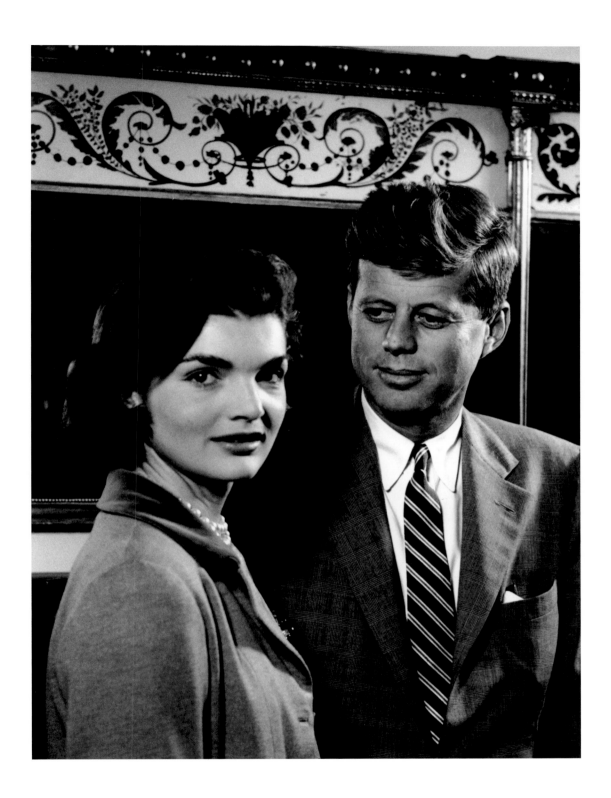

Senator and Mrs. John F. Kennedy, Hyannisport, Massachusetts, 1955

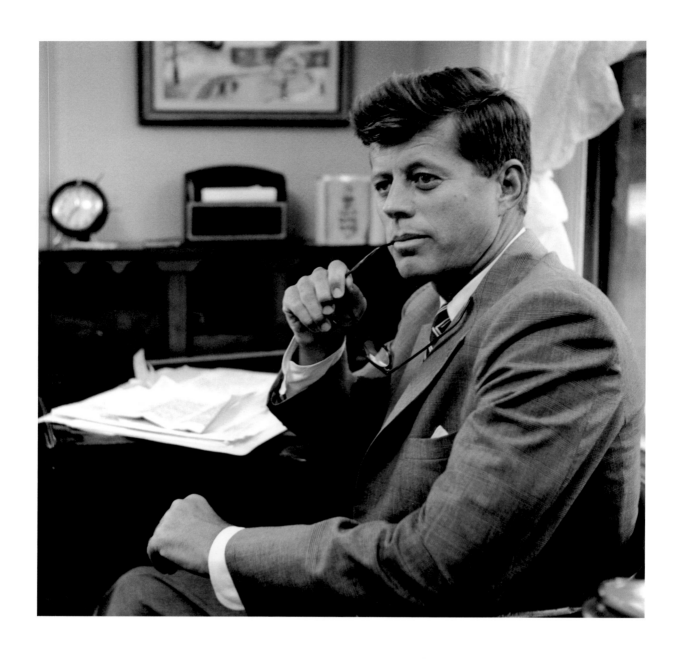

John F. Kennedy, Hyannisport, Massachusetts, 1955

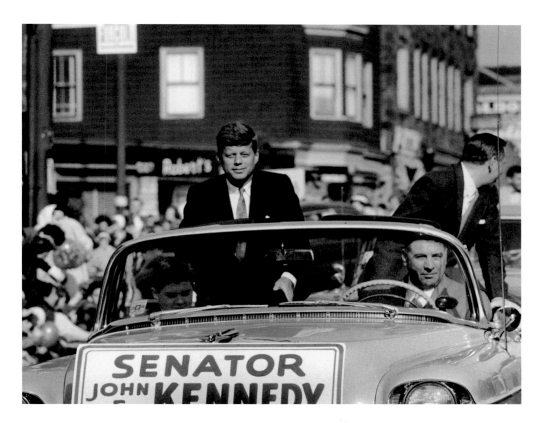

Senator John F. Kennedy, Foster Furcolo Parade, East Boston, 1956

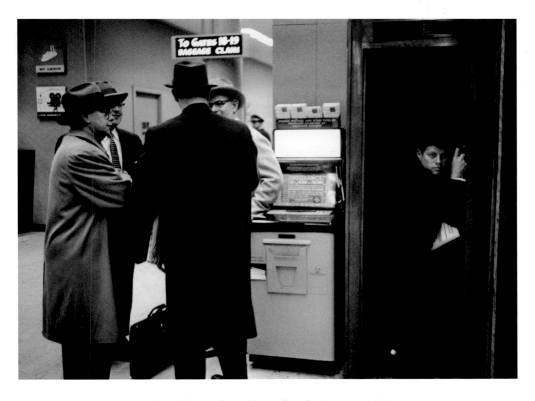

John F. Kennedy in Phone Booth, Boston, 1957

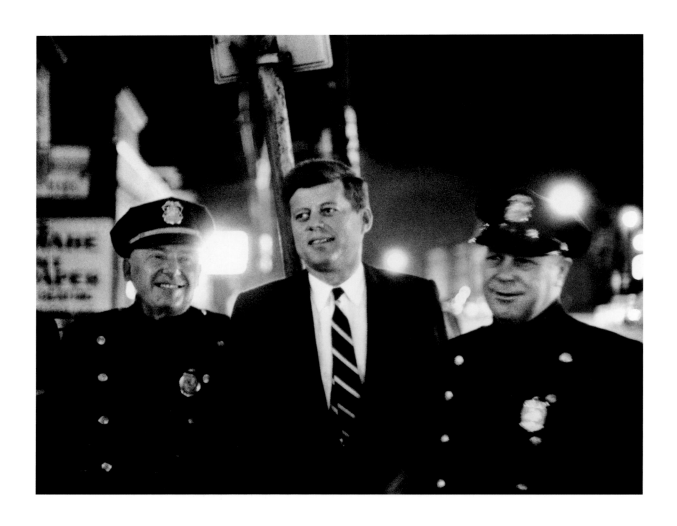

Boston's Finest, 1957

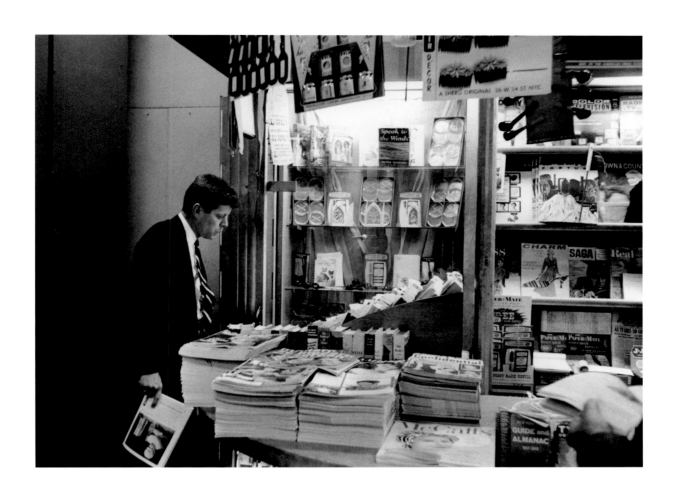

John F. Kennedy at Newsstand, Boston, 1957

Antique Purchase, Albany, Vermont, 1951

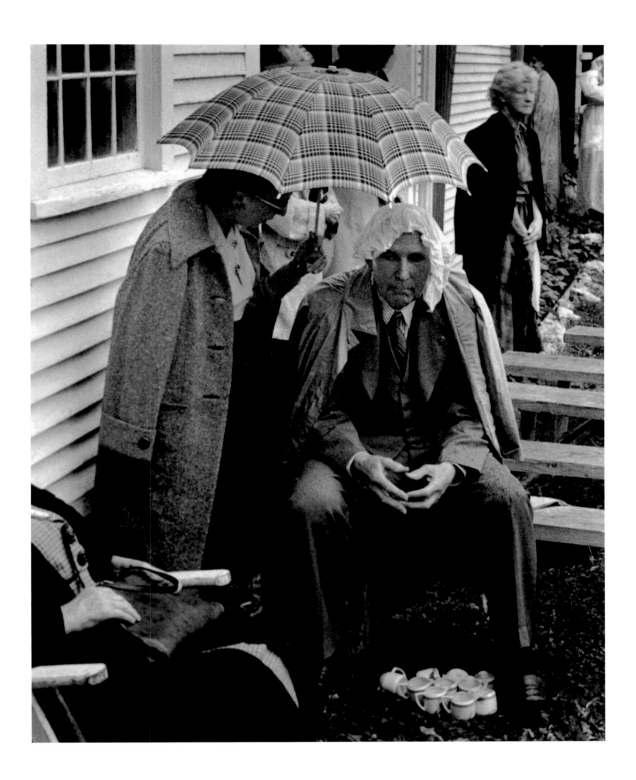

Couple at Auction, Albany, Vermont, 1951

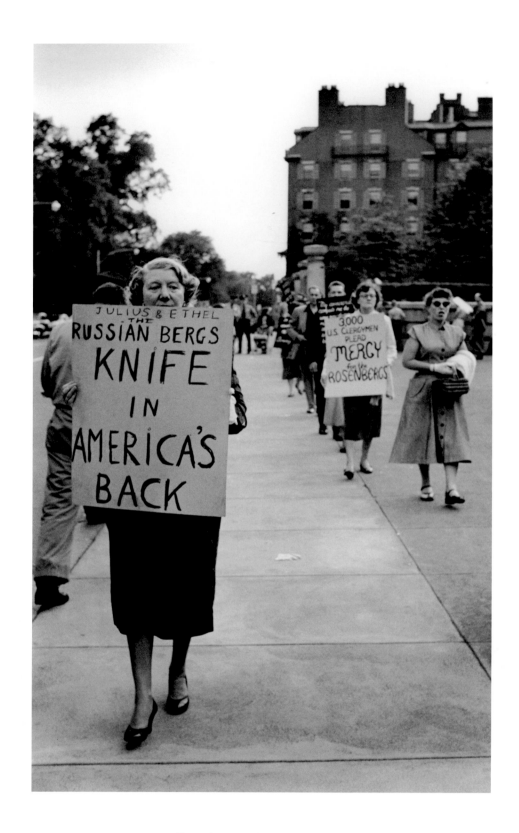

Rosenberg Vigil I, Boston, 1953

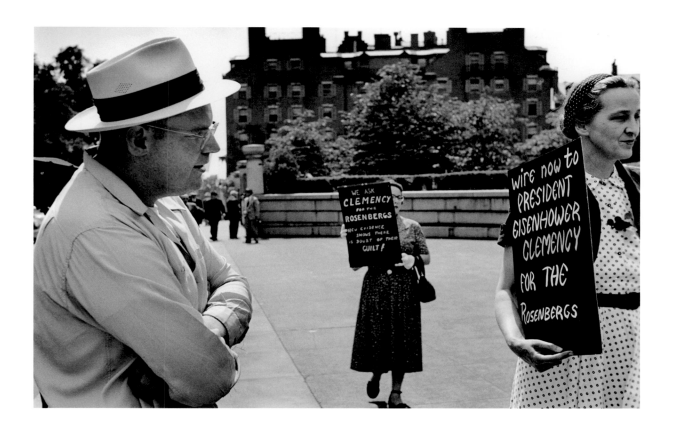

Rosenberg Vigil II, Boston, 1953

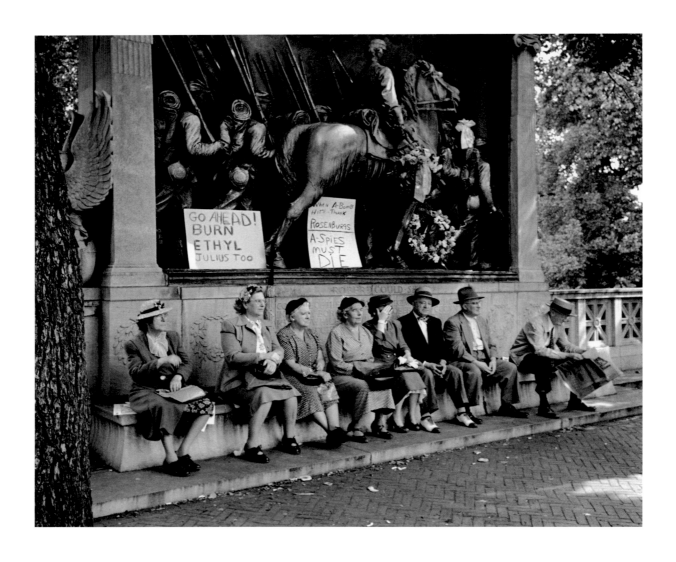

Rosenberg Vigil III, Boston, 1953

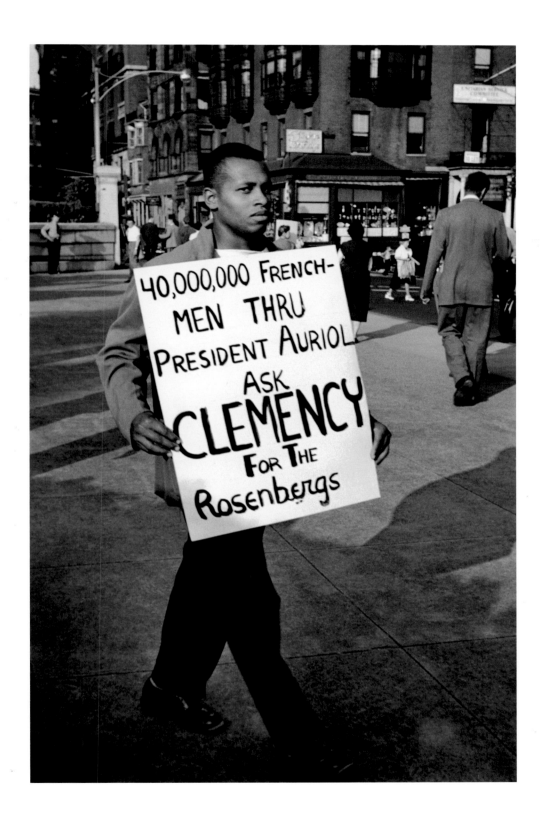

Rosenberg Vigil IV, Boston, 1953

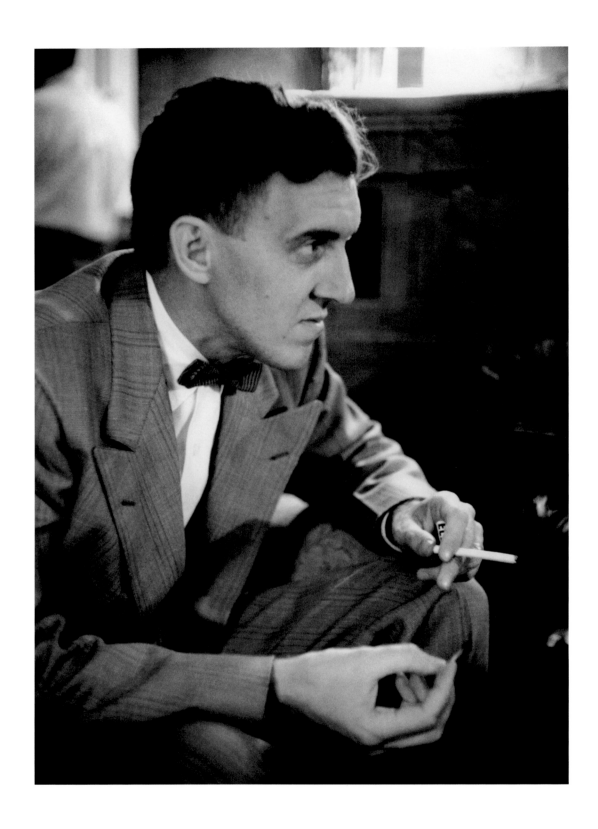

Edmund S. Muskie, Rumford, Maine, 1954

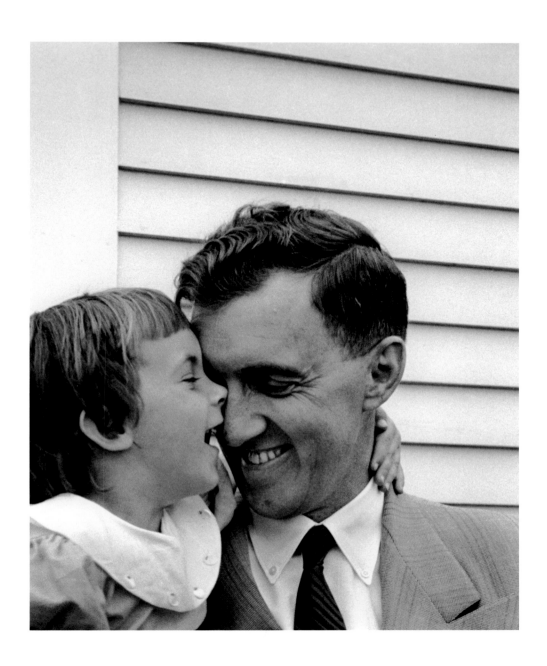

Edmund S. Muskie, with Daughter, Rumford, Maine, 1954

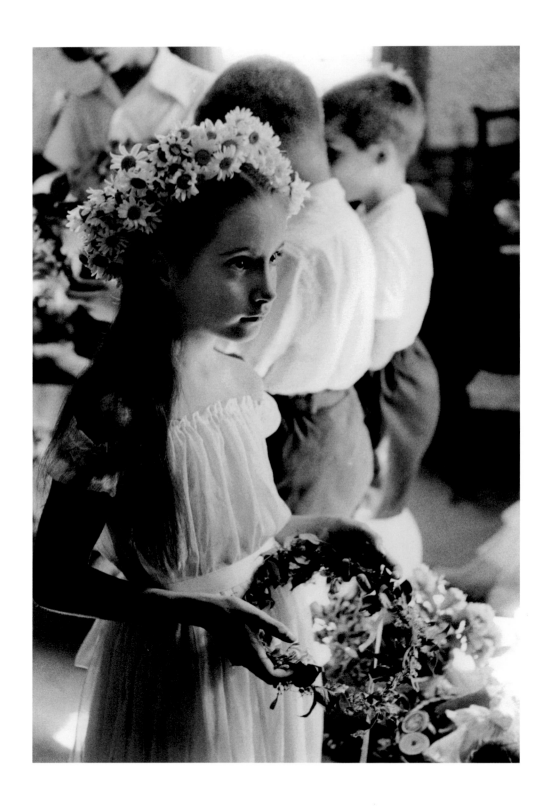

Girl with Wreath, Webster, New Hampshire, 1955

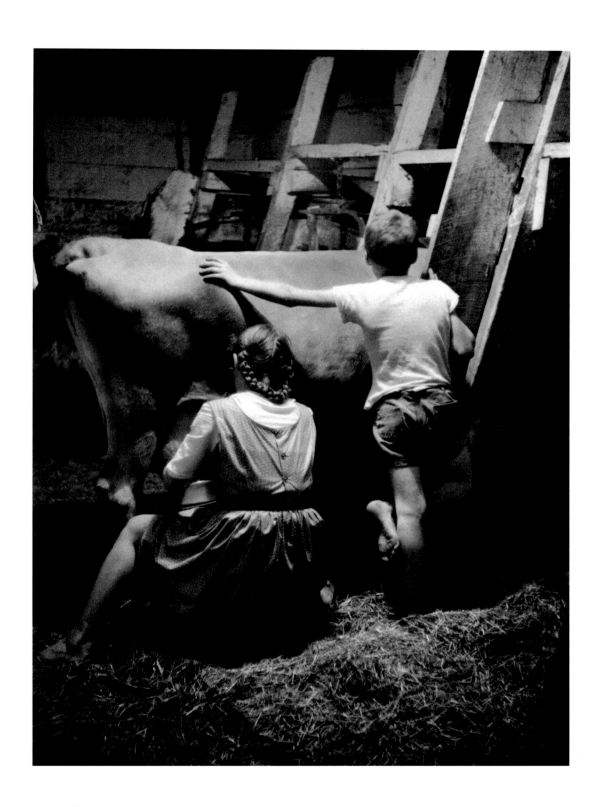

Evening Chores, Webster, New Hampshire, 1955

CREATING A PICTURE

Most professional photographers grapple with balancing commissioned work against their artistic output. Photography in the earlier twentieth century was most commonly seen as something akin to graphic design—a professional trade, but not necessarily a fine art. This view was shifting during the time that Reed was actively making photographs. Indeed, in 1954, Reed was given an exhibition at the DeCordova Museum in Lincoln, Massachusetts—an institution that was the first in the region to display contemporary New England art. With the photographs in this section, Reed was less interested in the transmission of fact than in sharing the more ineffable qualities associated with emotion—they are works that, like poetry, deal more with allusion than illustration. Though some were commissioned works, they took on a life of their own in the context of his personal work printed for exhibition rather than being submitted for publication.

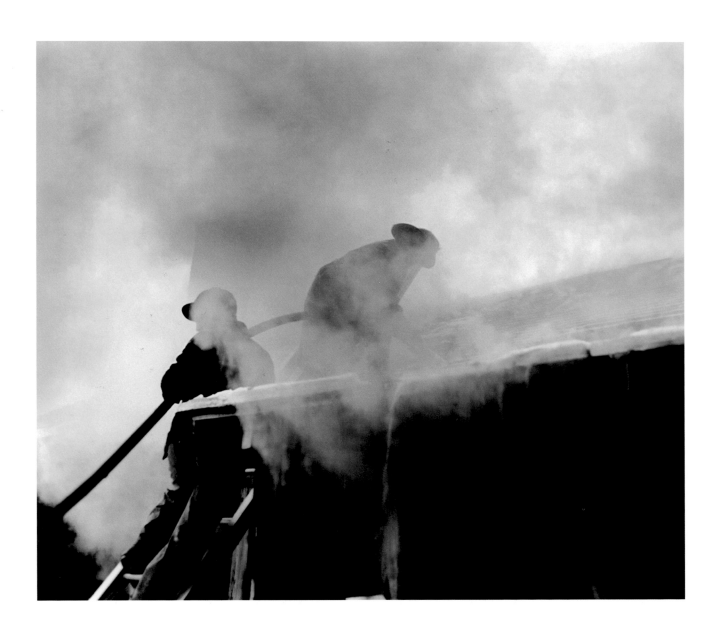

Stowe VFD, Stowe, Vermont, 1951

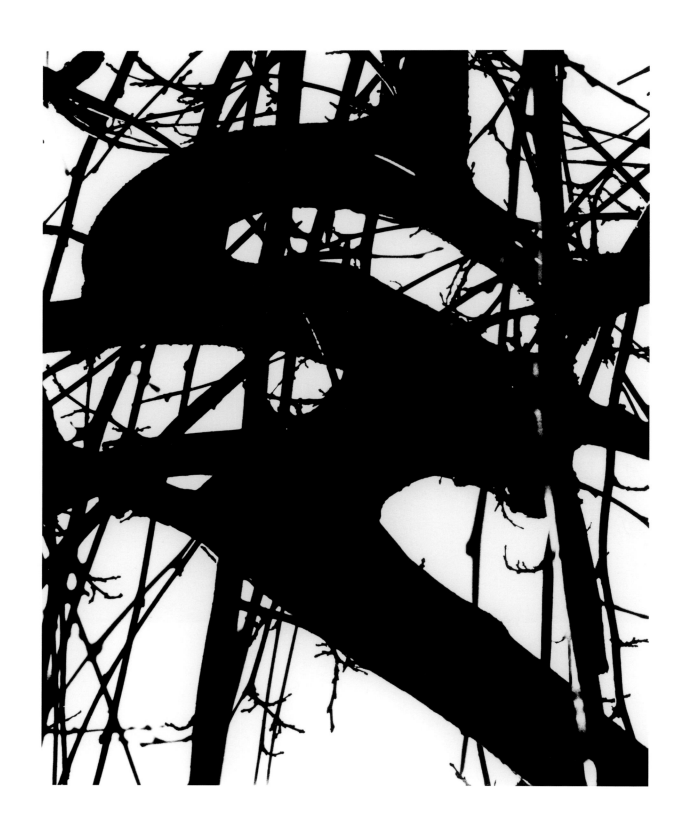

Tree Branches, Newport, Rhode Island, 1951

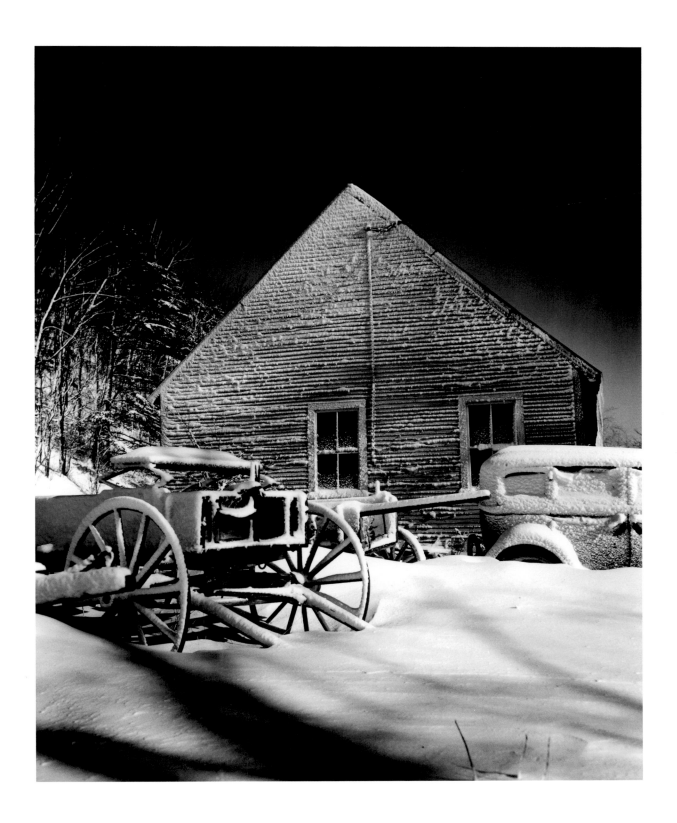

Twenty Below Zero, Waterbury, Vermont, 1951

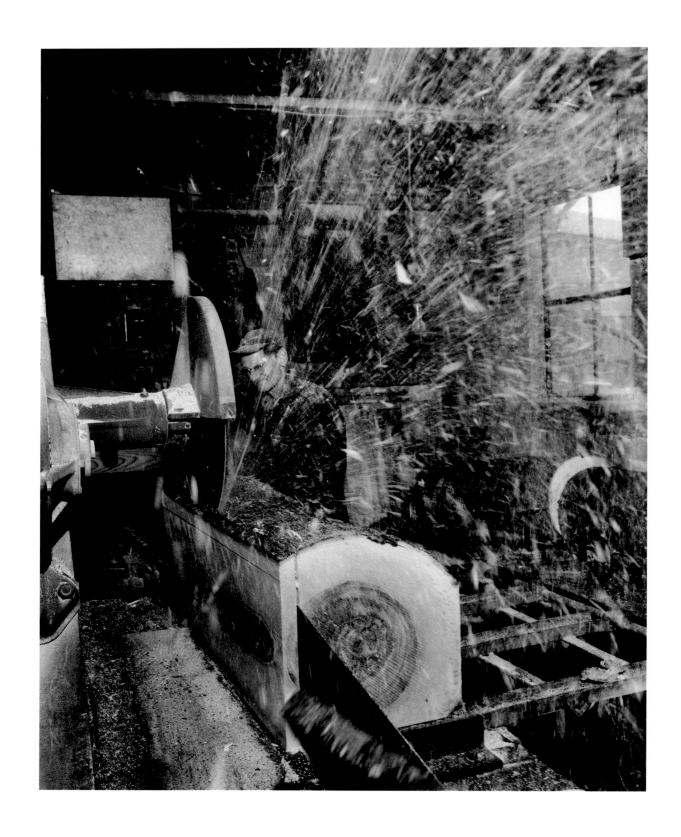

Adams Wood Mill, Stowe, Vermont, 1952

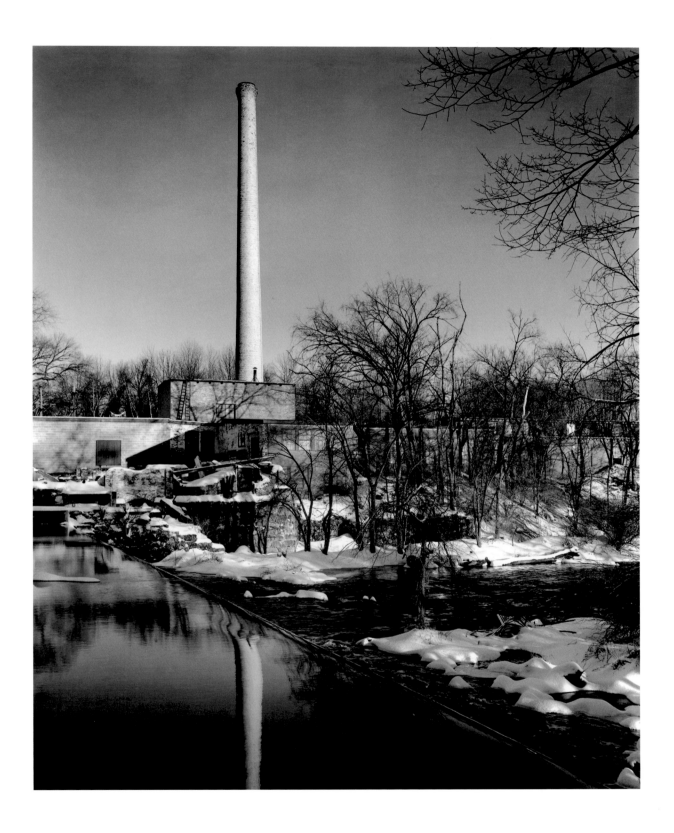

Charles River, Massachusetts, 1953

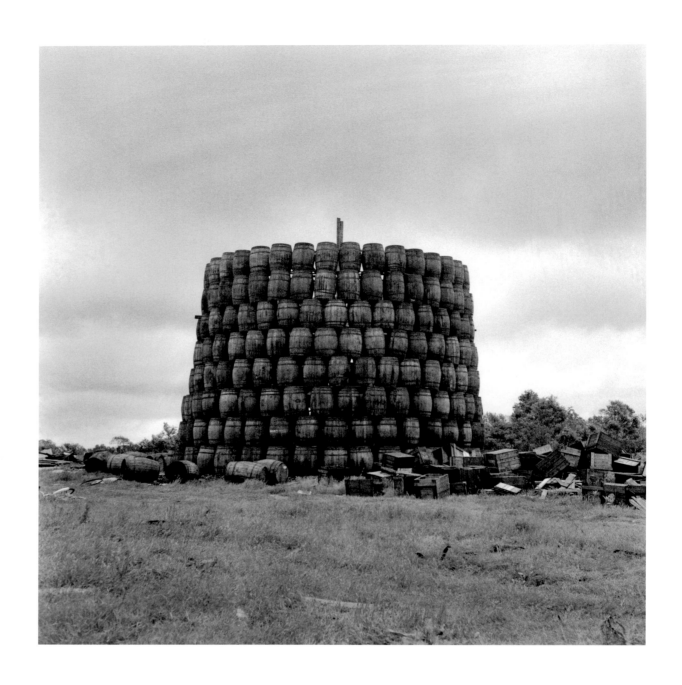

Bonfire Barrels, Deerfield, Massachusetts, 1955

"Texas Tower," an offshore radar warning station, off Cape Cod, Massachusetts, 1955

Horses, Vermont/Quebec border, 1958

Winter, Stowe, Vermont, 1963

Dump Fire, Stowe, Vermont, 1971

Crushed Cars, Morrisville, Vermont, 1971

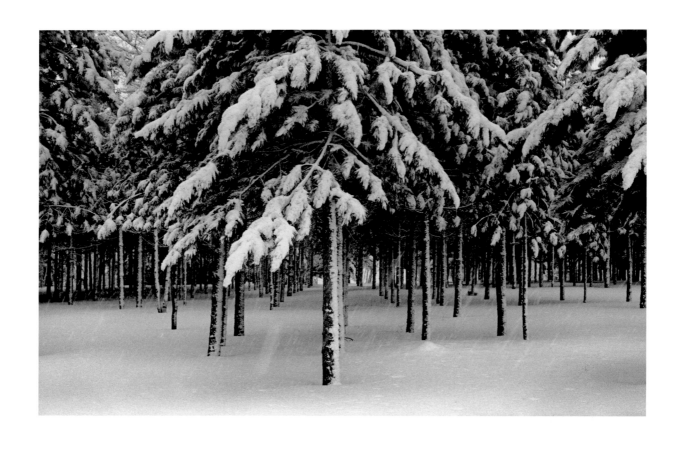

Evening Snowfall, Stowe, Vermont, 1971

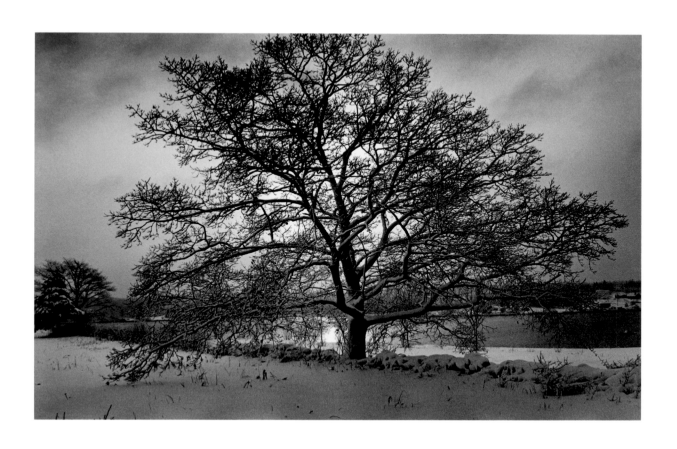

Pemaquid Tree, Pemaquid Harbor, Maine, 1972

PORTRAITS

At their best, portraits offer an instructive view into the dynamic between sitter and photographer. Reed made portraits throughout his career, many of which reveal something of both participants in the creation of the image. This section includes the famous, such as Robert Frost and T. S. Eliot, and others unknown to most of us whose faces are no less compelling. Some were friends or acquaintances, such as the artist Al Duca, but others were people he was assigned to cover. Reed recalls the particular agony of waiting for the Eisenhower portrait while the president was on vacation in Newport: "The only reason I was there was because it was *Life*'s policy to have a photographer on hand in case something should happen, but nothing ever happened. He came out in the morning and played golf and he went home and had a nap, then came out and played golf again." Not surprisingly, the great Eisenhower portrait included here shows the president, golf club in hand.

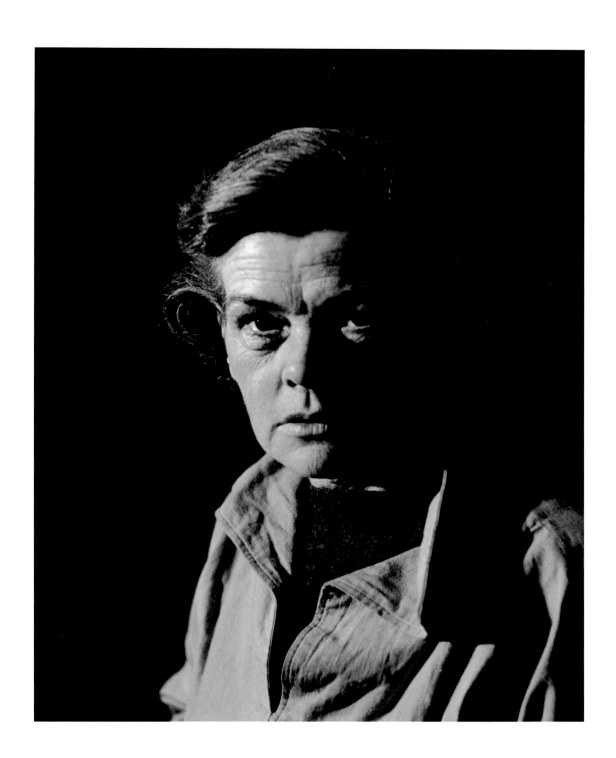

Audrey, Stowe, Vermont, 1949

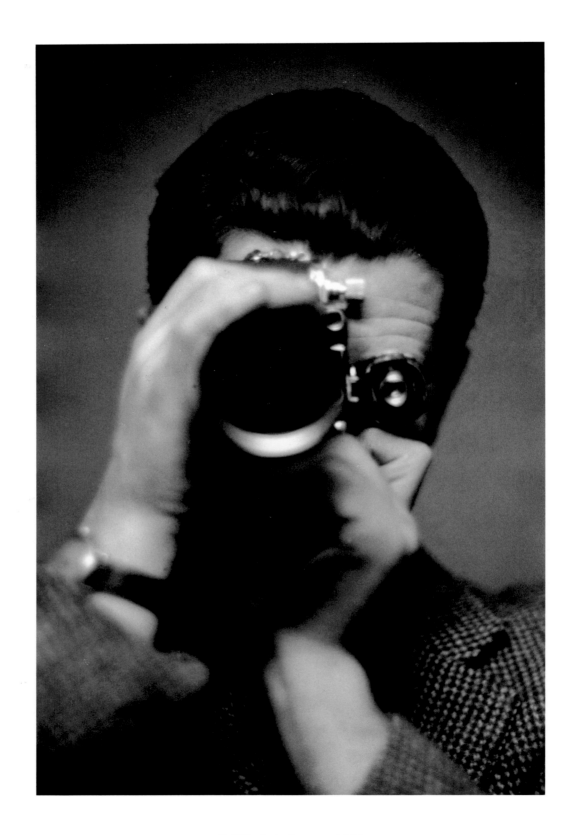

Self Portrait, Boston, 1953

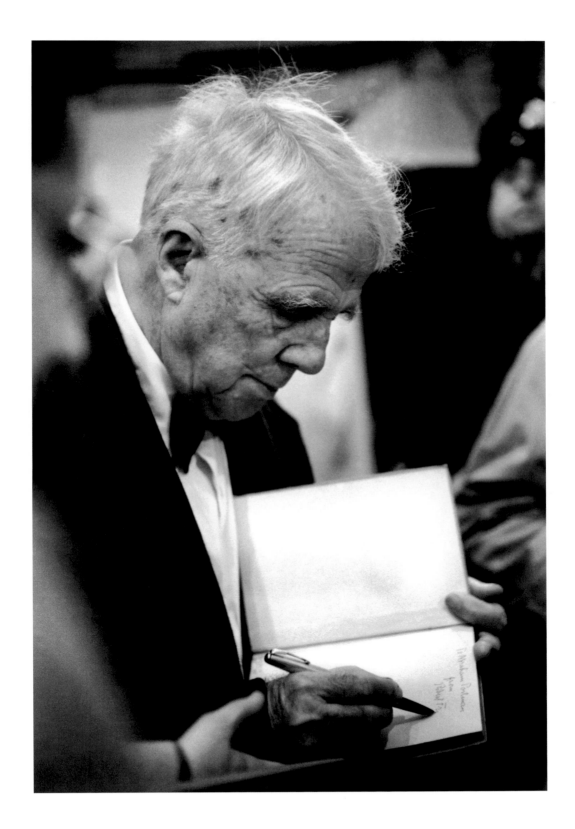

Robert Frost, Boston, 1954

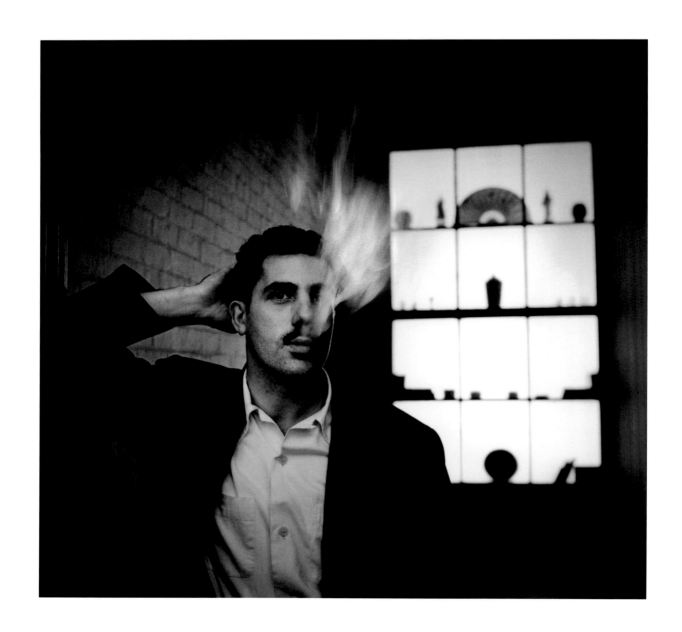

Al Duca, Boston, 1954

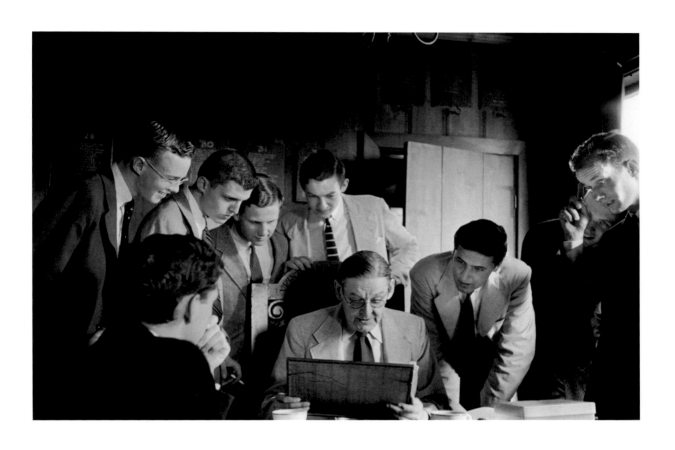

T. S. Eliot, Cambridge, Massachusetts, 1955

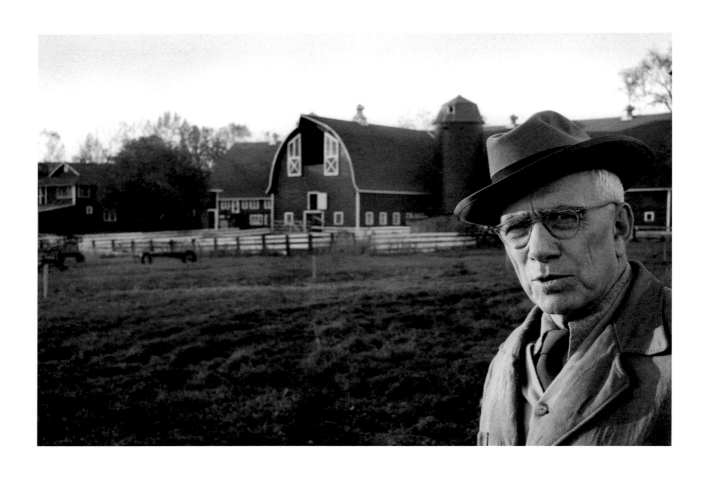

Senator George Aiken, Putney, Vermont, 1956

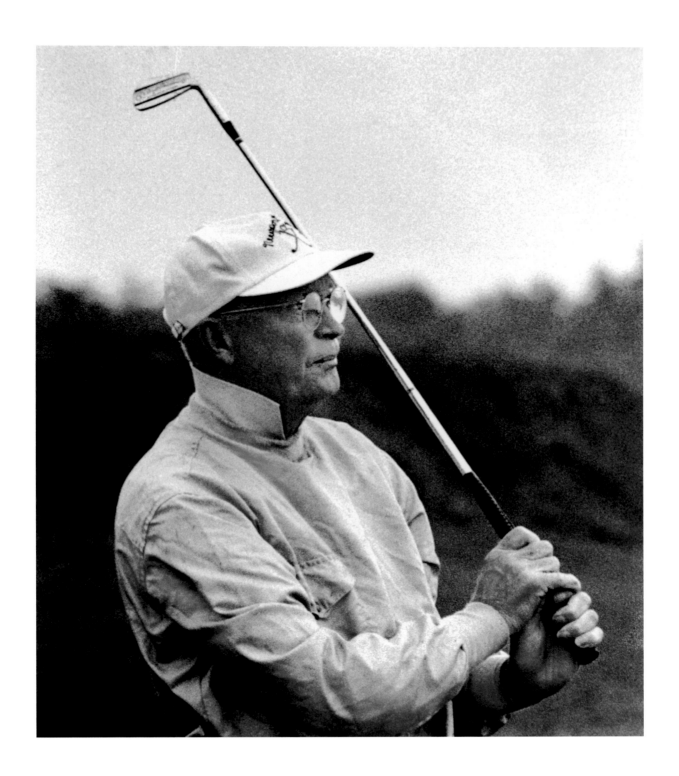

President Dwight D. Eisenhower, Newport, Rhode Island, 1958

URBAN LIFE

Reed was quite adept at street photography. His eye was often drawn to the telling, casual moments that appear to those who spend time waiting for them. Citing Henri Cartier-Bresson as his chief influence, Reed looked for what the French photographer described as the "decisive moment"—that fleeting instant when several factors coalesce to tell a story. For example, one mid-1950s image depicts a ditch-digger on Boston's Beacon Hill being assiduously ignored by three denizens of the city's toniest neighborhood. Reed's instincts drew him to document this social contrast. Sometimes the "decisive moment" is less of an instant than a key moment in history. For example, rebuilding the Old North Church in Boston after Hurricane Carol damaged the steeple in 1954 was a matter of great civic pride in that city. The church embodied the ideals of the Revolutionary War like few other icons.

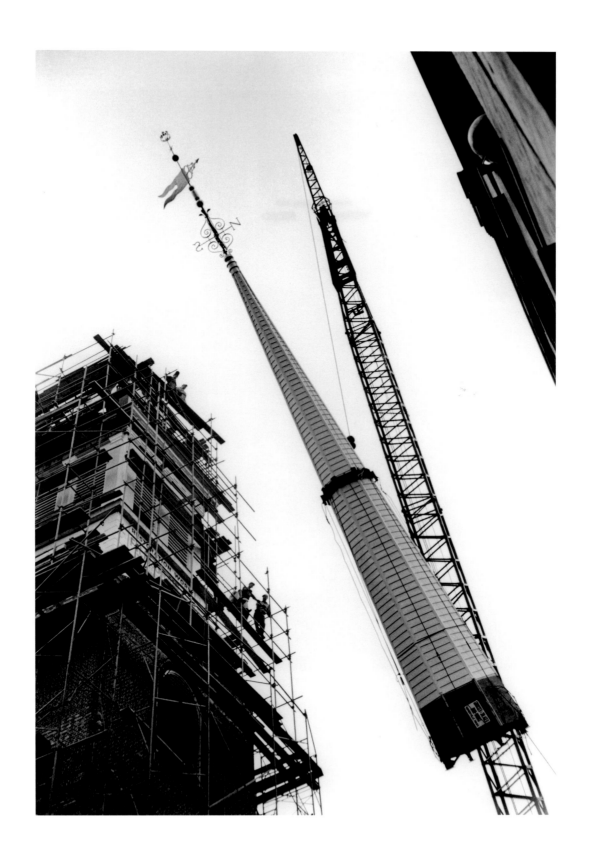

Old North Church, Boston, 1954

Boston Globe, Boston, 1956

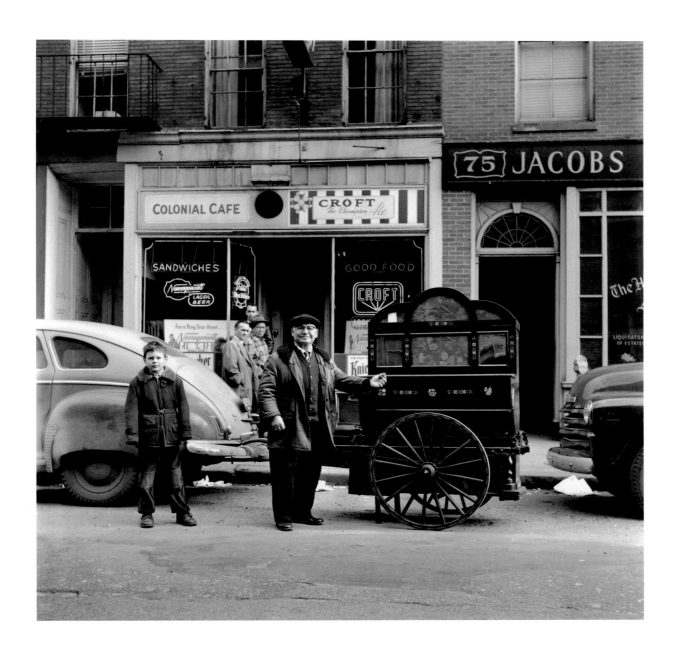

Organ Grinder, Boston, 1955

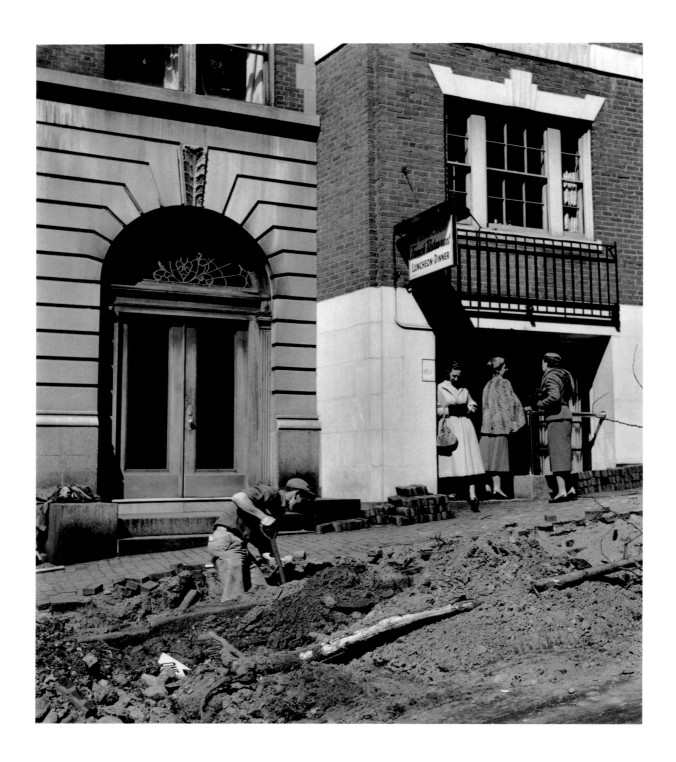

Mount Vernon Street Repairs, Boston, 1955

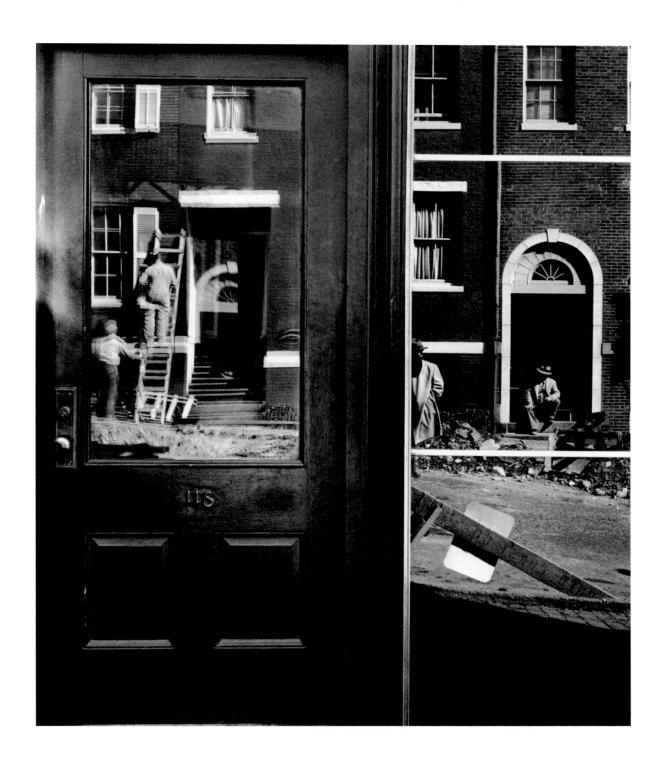

Mount Vernon Street Reflections, Boston, 1955

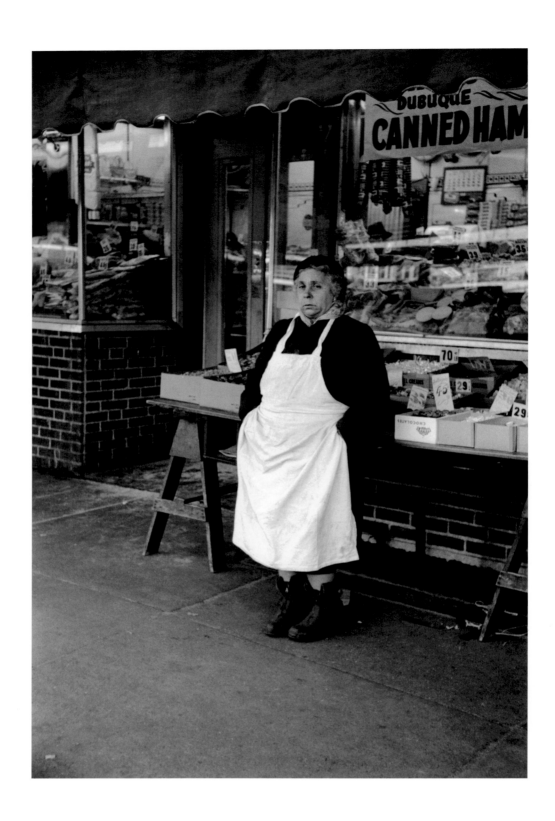

North End, Boston, 1955

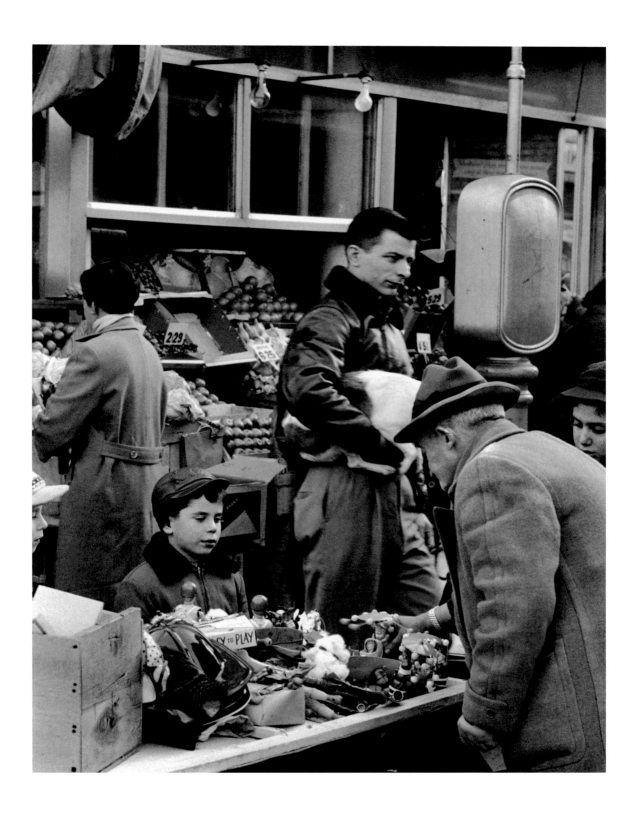

Boston Vendor, 1955

RURAL LIFE

This section addresses Reed's longstanding interest in defining the idea of "New England" as more than a geographical distinction. Though there are overlaps with other sections of the book, Reed's conscious construction of a body of images reflective of his ideal for what New England should look like deserves special attention. Like many other regional practitioners, Reed focused attention on a special range of subjects he considered exemplary. He worked to demonstrate the continued validity of rural, agrarian-based life at a time when modernity seemed to be leaving both the lifestyle and its attendant social mores behind. Many of the photographs in this section were created at a time when Reed had himself turned from the city, preferring the life he found in rural Vermont.

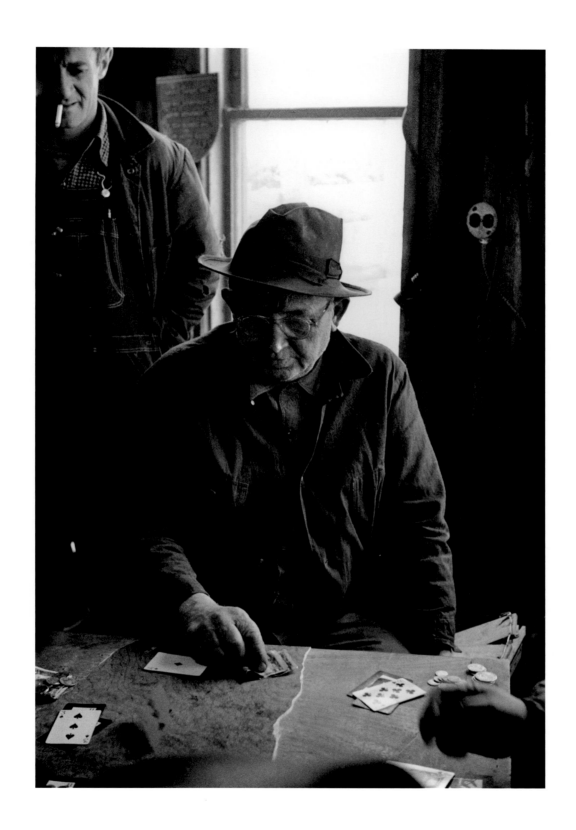

Poker Player, Morrisville, Vermont, 1950

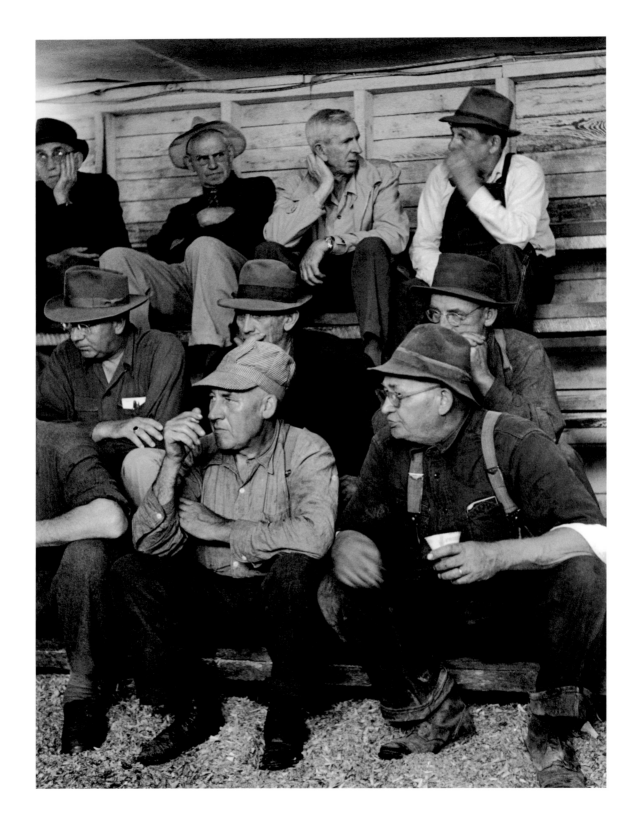

Men at Cattle Auction, Morrisville, Vermont, 1953

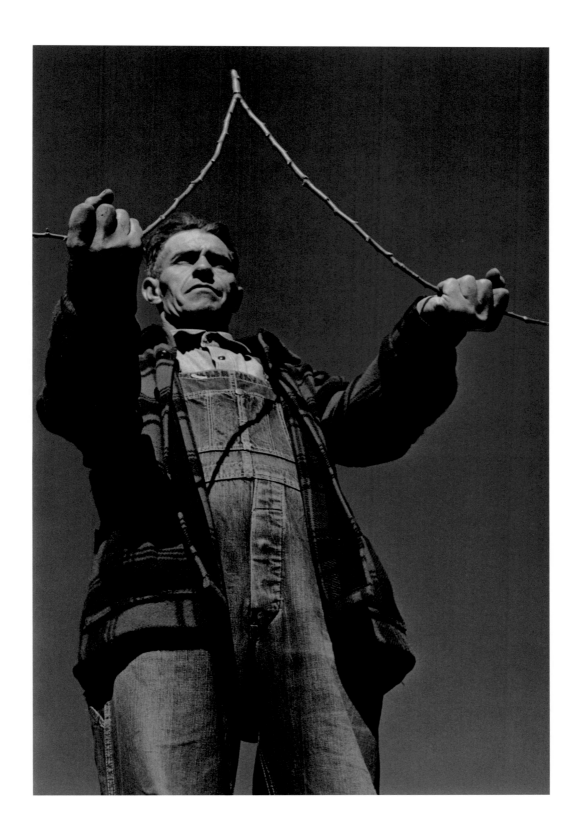

Dowser, Plainfield, Vermont, 1953

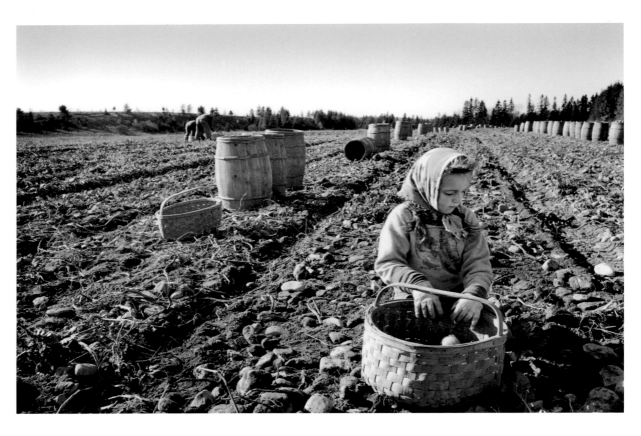

Aroostook County Potato Picking, Maine, 1954

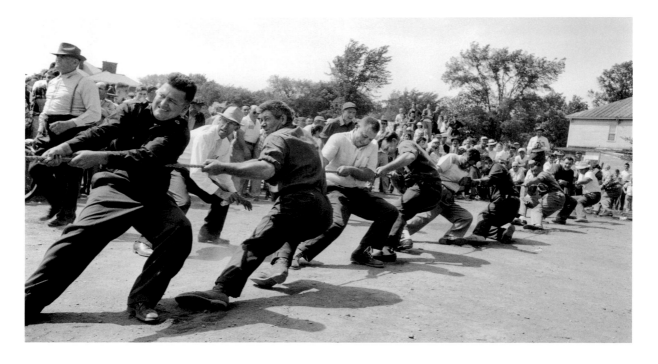

Tug of War, Caledonia County, Vermont, 1958

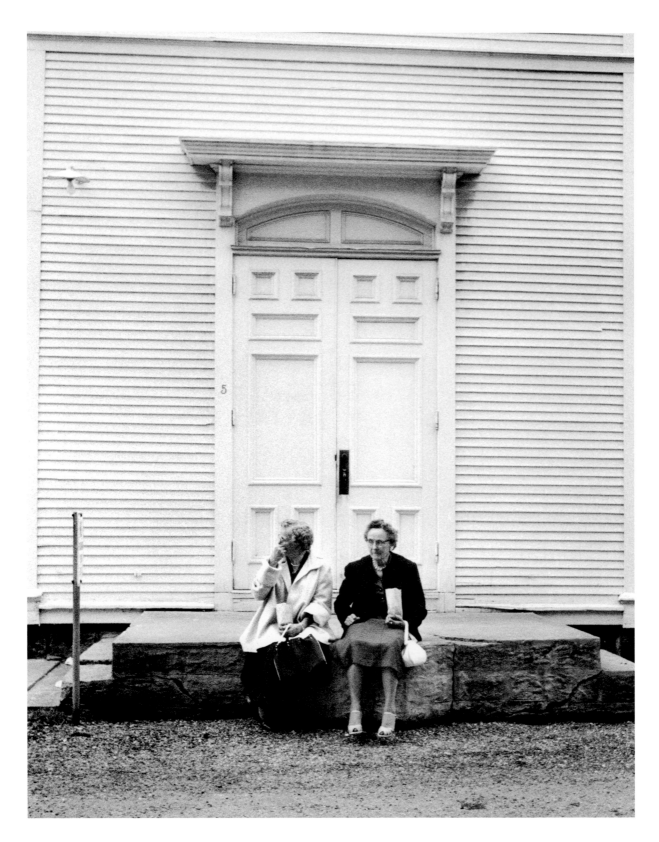

Waiting, Enosburg Falls, Vermont, 1958

Northern Vermont Family, 1960

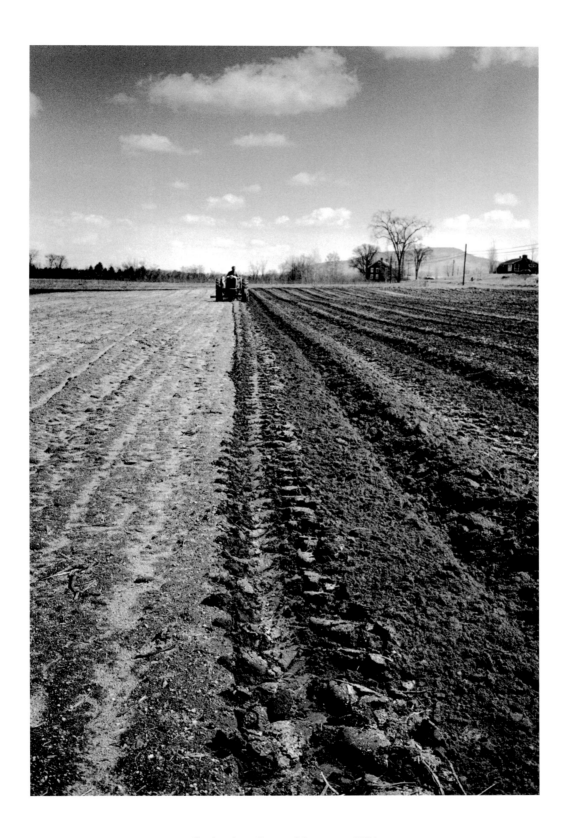

Springtime, Stowe, Vermont, 1971

TELLING MOMENTS

For many years, at the very back of *Life* magazine the editors included a particularly witty photograph in the section titled "Parting Shots." This title's wonderful double entendre perfectly captures the spirit of the images selected for this section. Many of them were shot as part of a series but work better on their own. Often bittersweet, the classic "Parting Shot" image works on multiple levels, demonstrating photography's ability to speak beyond words. Here we find the baby in the carriage below a sign reading, "Fancy Plump Northern Turkeys: Ready for the Oven"; the awe of the young gentleman in the park studying the frozen beauty in a marble sculpture; and the woman at the *The Atlantic Monthly*'s one-hundredth anniversary party specifying her preference for just a small drink. The perfect parting shot combined Cartier-Bresson's idea of the "decisive moment" with a keen social wit.

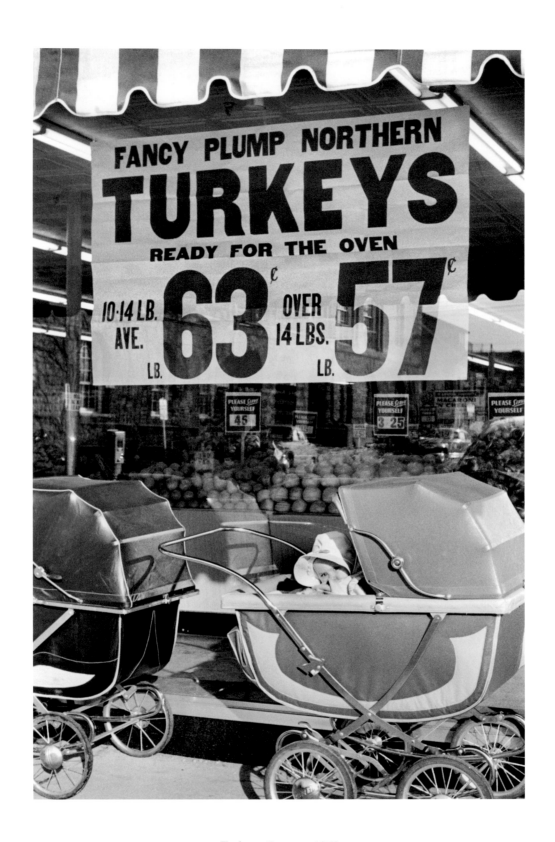

Turkeys, Boston, 1952

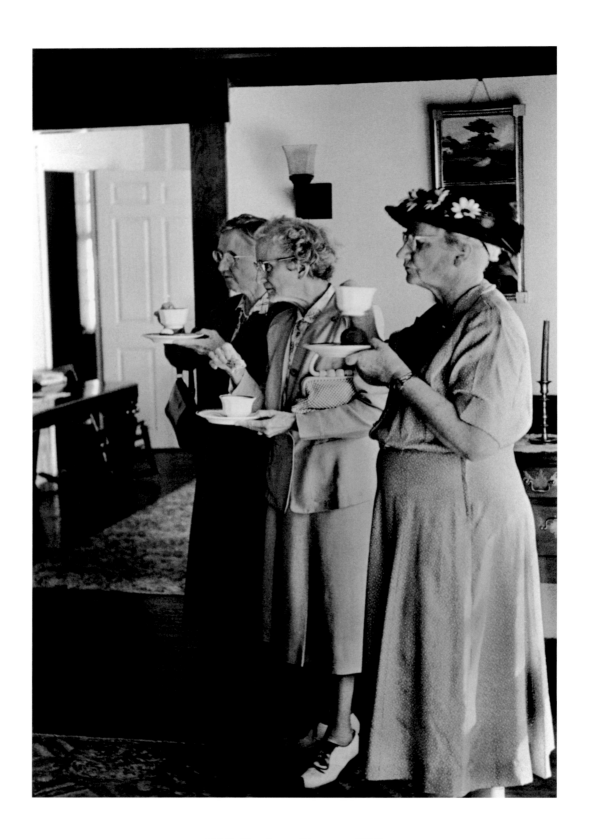

DAR, Newbury, Vermont, 1953

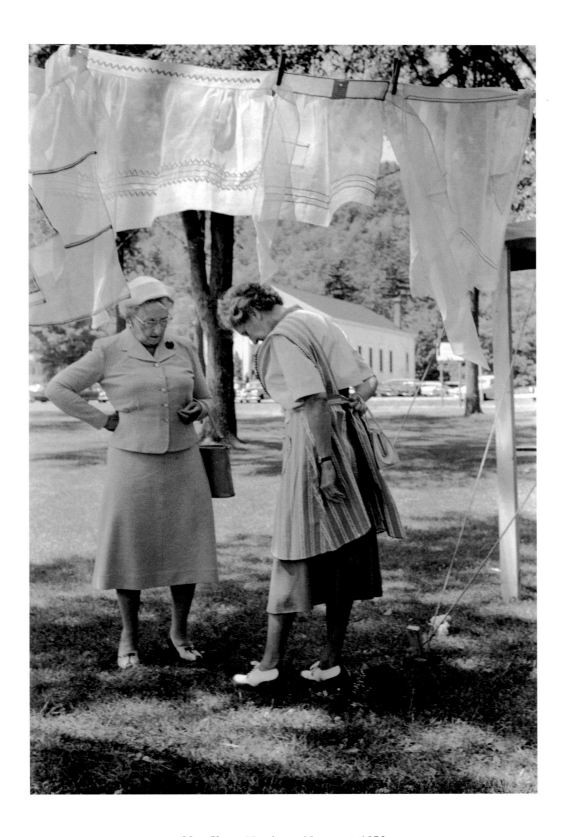

New Shoes, Newbury, Vermont, 1953

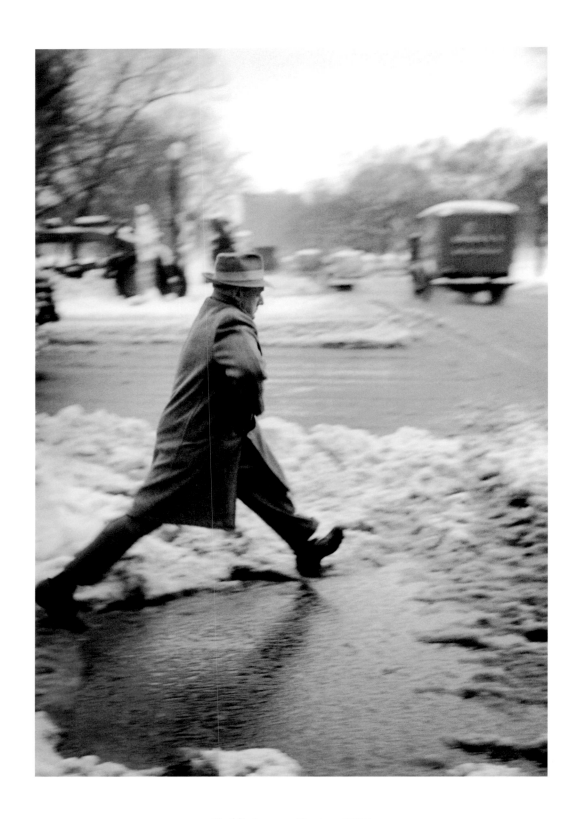

Puddle Jumper, Boston, 1953

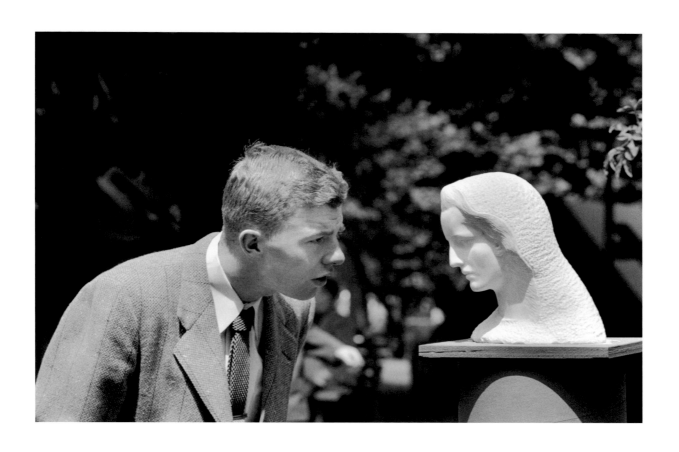

Boston Arts Festival, 1954

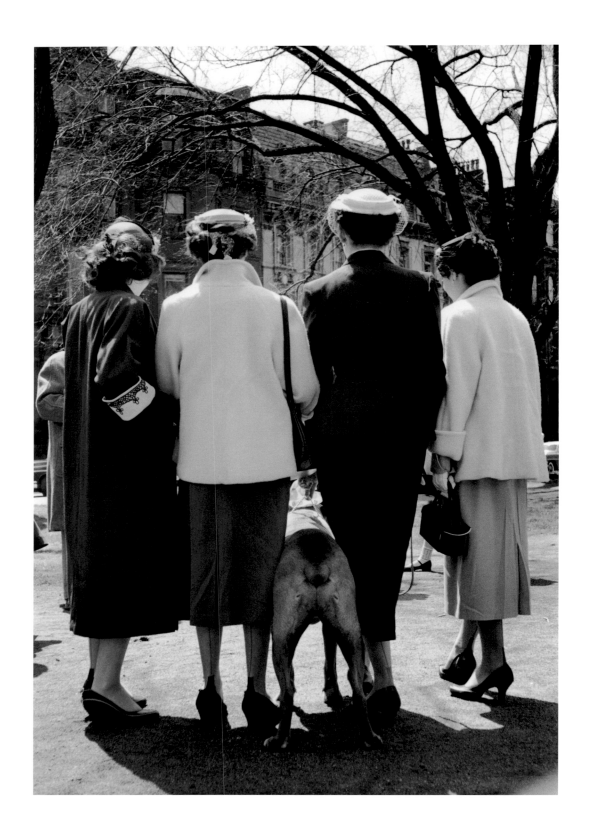

Easter Parade, Boston, 1954

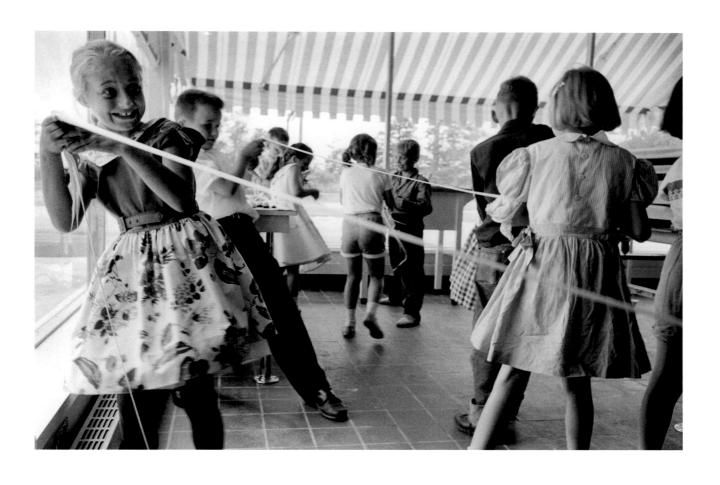

Taffy Pull, Peabody, Massachusetts, 1955

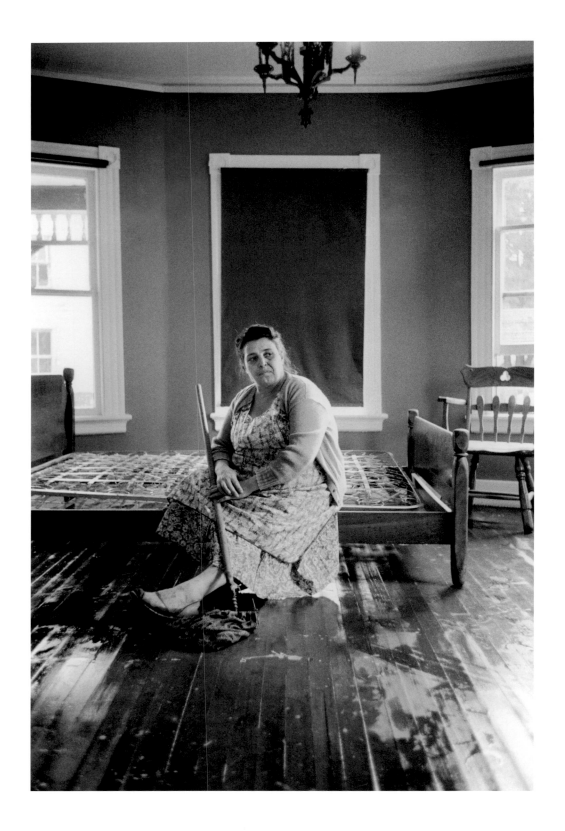

After the Flood, Ansonia, Connecticut, 1955

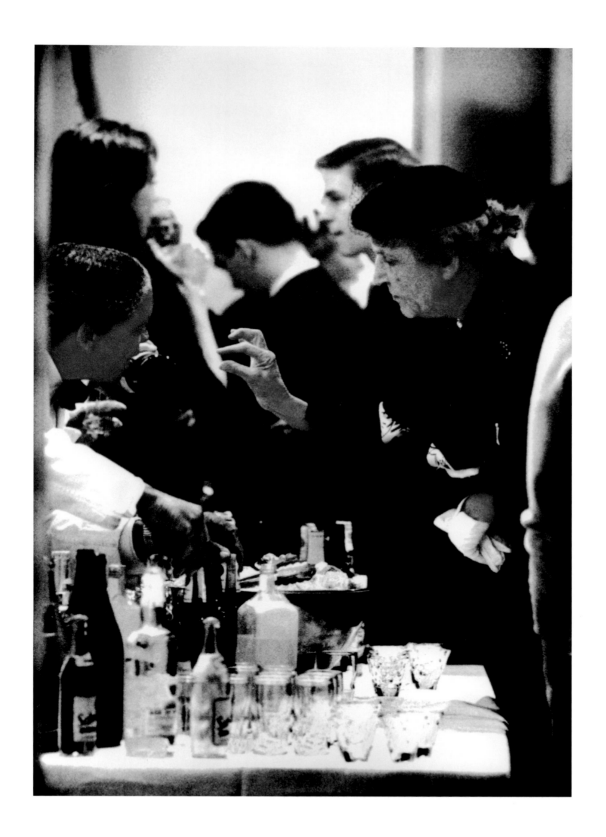

Teenie Weenie, Boston, 1957

AT THE FAIR

Taking photographs that Reed made at the Tunbridge Fair in Vermont over several years as an example, this section offers the opportunity to analyze a particular theme in Reed's work. For centuries, artists and authors, poets and filmmakers have used the carnival as a metaphor for society. The fair likewise provided Reed with ample opportunities to contemplate the spectacle of life displayed on the midway. The Tunbridge Fair was a particularly large fair with a long-standing reputation for life's seamier pursuits. Drinking, gambling, and "girlie shows" were standard fare at Tunbridge. But so too were the traditional agrarian talents. The contrast between these two spheres of activity offered Reed special opportunities to reflect on the range of human pursuits.

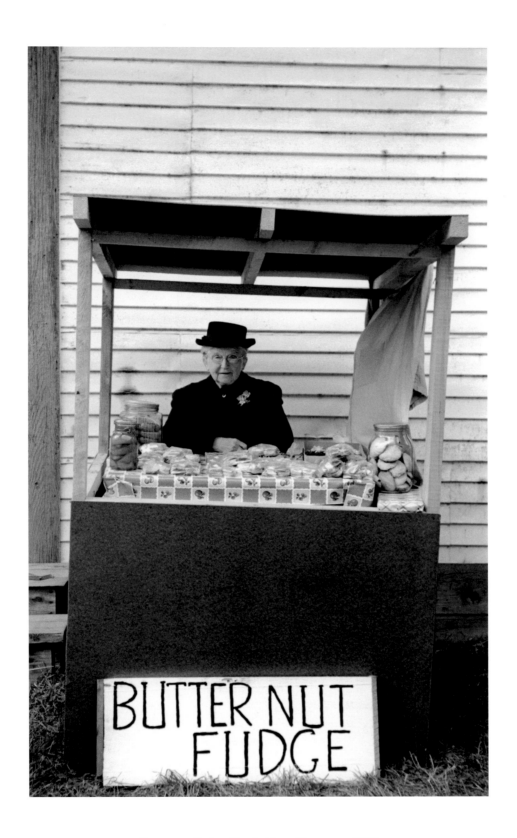

Butternut Fudge, Tunbridge, Vermont, 1955

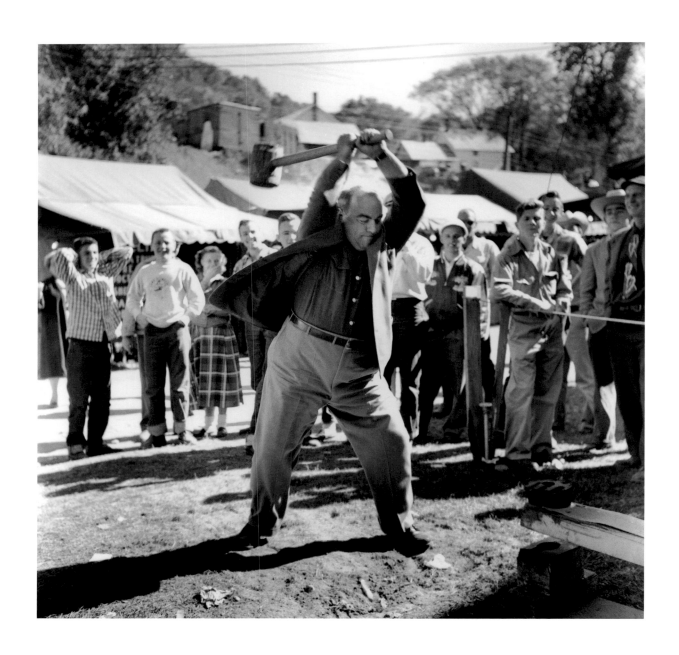

Country Fair, Tunbridge, Vermont, 1955

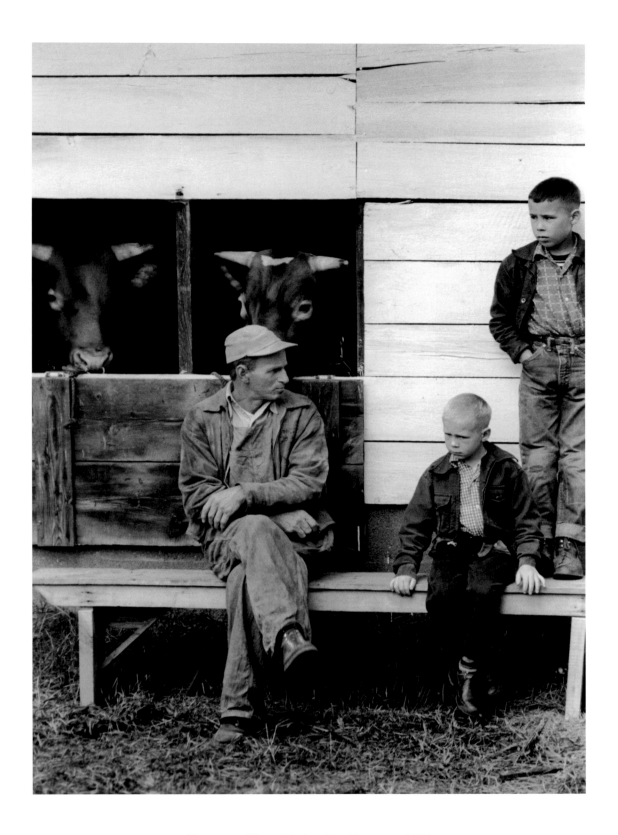

Farmer and Boys, Tunbridge, Vermont, 1955

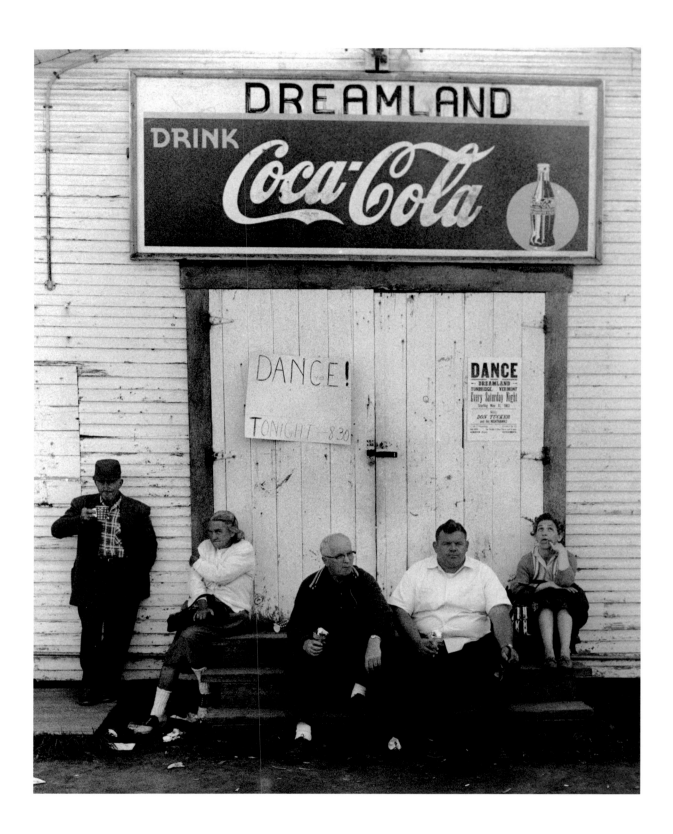

Dreamland, Tunbridge, Vermont, 1963

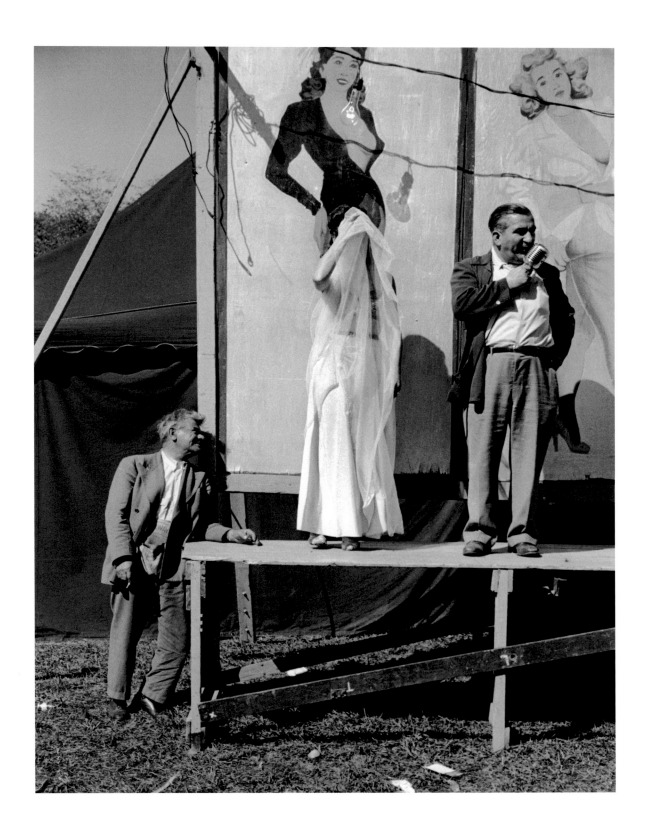

Tunbridge Fair Burlesque, Tunbridge, Vermont, 1963

YOUTH

Children interested Reed intensely throughout his career. Like canaries in a coal mine, Reed's images of children sometimes warn of a brash future. Over and again, his camera explored the subject of youth and the changing social mores discernible in their self-expression. This section includes photographs that range from small-town farm girls to big-city boys sporting fresh pompadours. It also features an image from 1971 depicting long-haired young men and women dancing at an outdoor concert. By then, the times had changed.

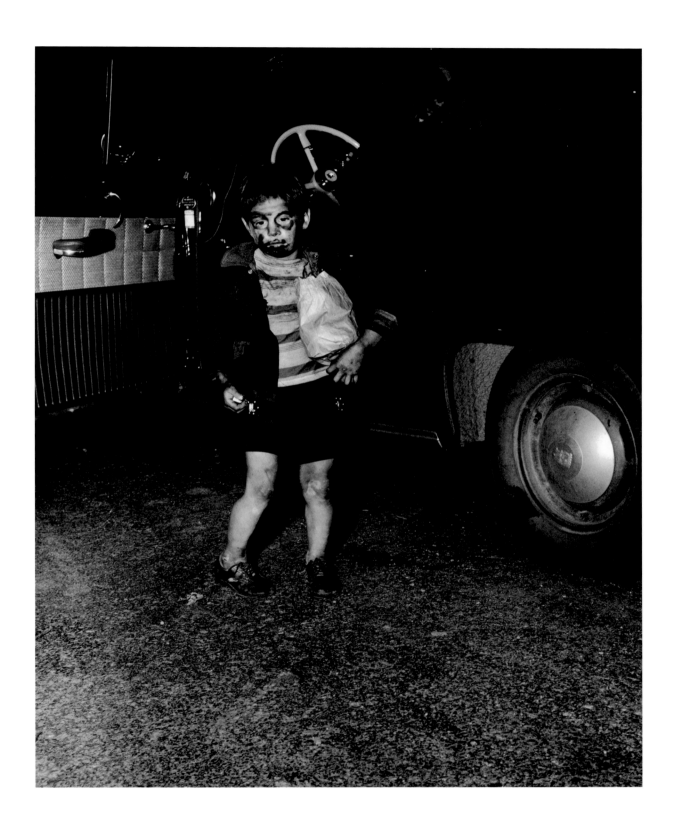

Halloween, Stowe, Vermont, 1951

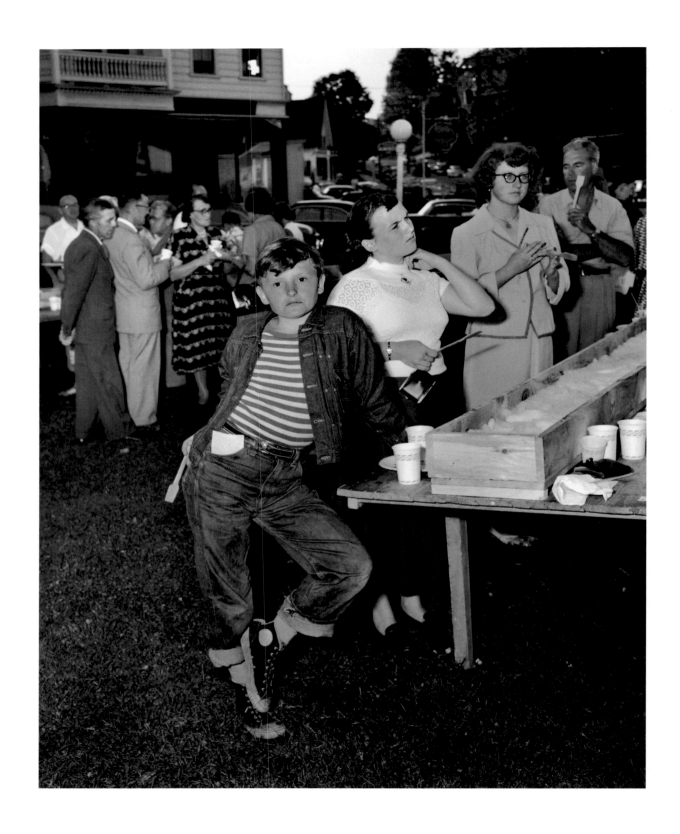

Boy with Attitude, Barton, Vermont, 1952

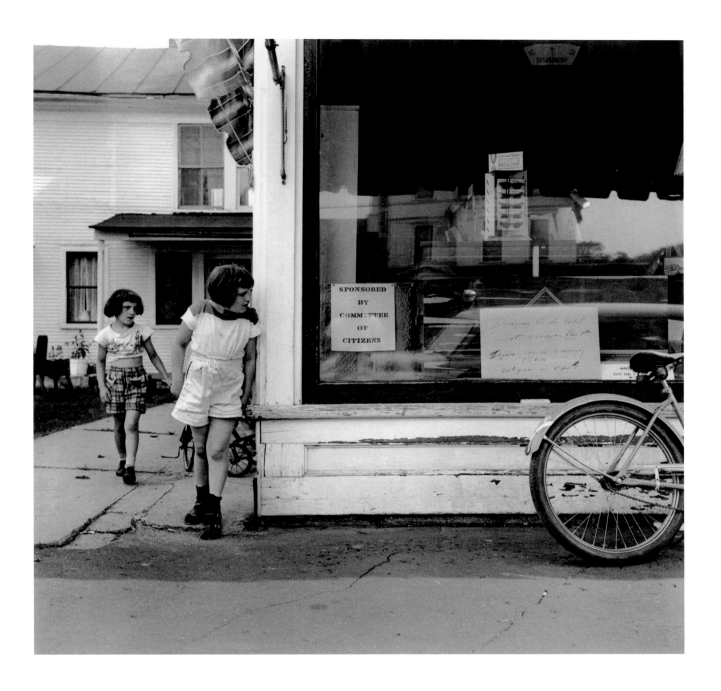

Saturday Afternoon, Stowe, Vermont, 1952

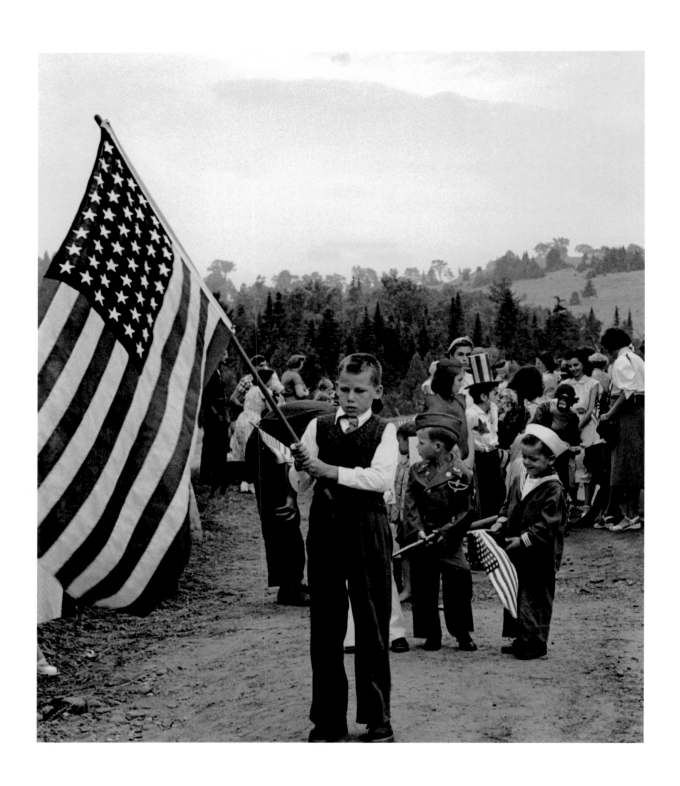

Fourth of July, North Danville, Vermont, 1952

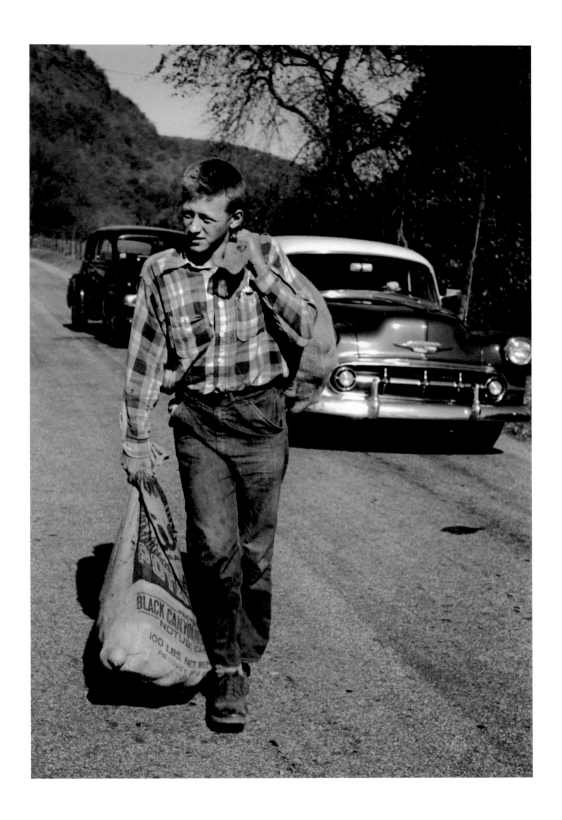

Boy with Potato Sack, East Whately, Massachusetts, 1954

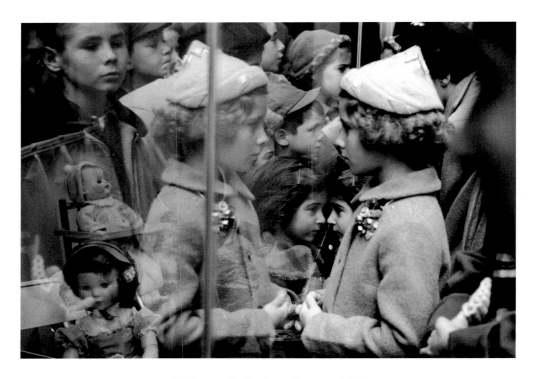

Christmas Reflections, Boston, 1955

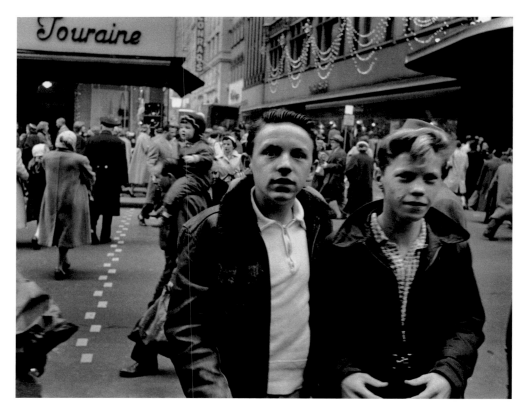

Washington Street, Boston, 1955

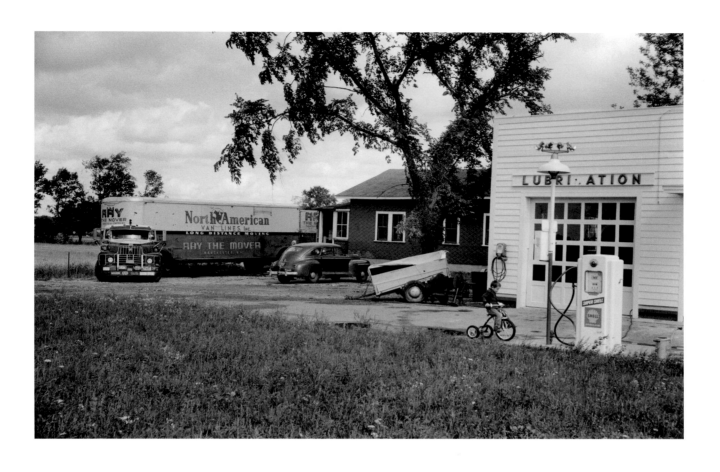

Moving Day, Pease Air Force Base, Portsmouth, New Hampshire, 1956

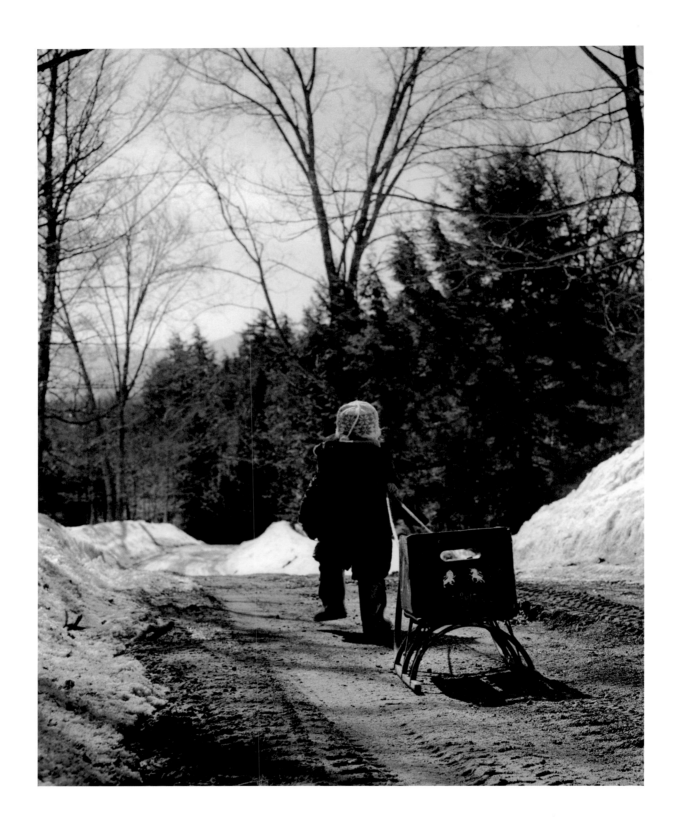

In Search of Snow, Stowe, Vermont, 1964

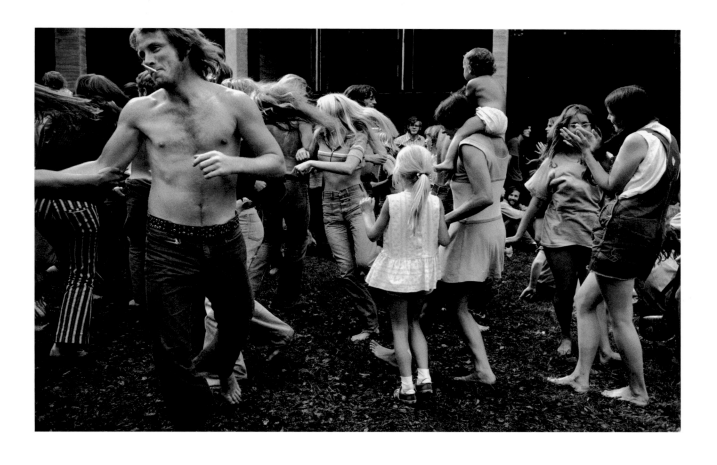

Outdoor Concert, Bolton, Vermont, 1971

VERNER REED was born in Denver, Colorado. He attended Milton Academy and Harvard College before serving with the Army Air Corps during World War II. He settled in Stowe, Vermont, after the war, but soon moved to Boston, where he began covering New England for *Life* magazine. His images also have appeared in *Fortune, Paris Match, Time,* and *Vermont Life*. He was one of the first photographers to have his work exhibited at the DeCordova Museum in Lincoln, Massachusetts. Also noted for his sculpture, jewelry making, and silversmithing, Reed lives in Maine.

JOHN R. STOMBERG is an art historian with a specialty in the history of photography. He is currently the associate director of the Williams College Museum of Art.

HISTORIC NEW ENGLAND is presented by the Society for the Preservation of New England Antiquities. It is the oldest, largest, and most comprehensive regional preservation organization in the country. Historic New England offers a unique opportunity to experience the lives and stories of New Englanders through their homes and possessions. Learn more at www.HistoricNewEngland.org.